painted paper

ART WORKSHOP

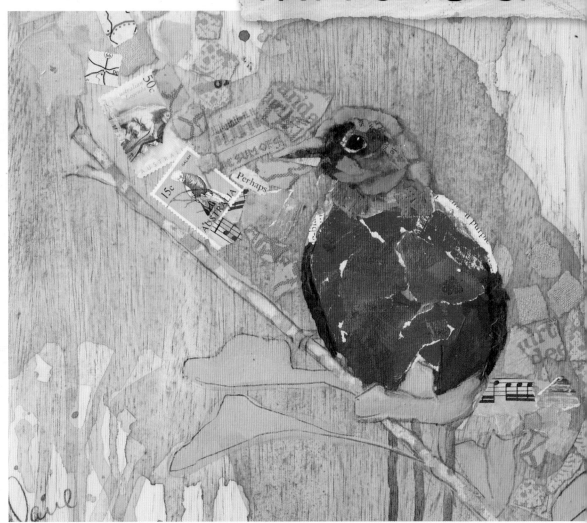

Easy and Colorful Collage Paintings

Elizabeth St. Hilaire

NORTH LIGHT BOOKS

Contents

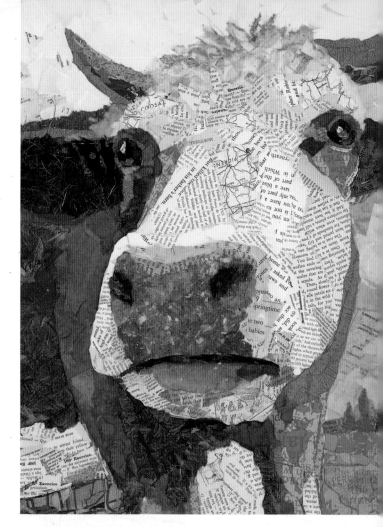

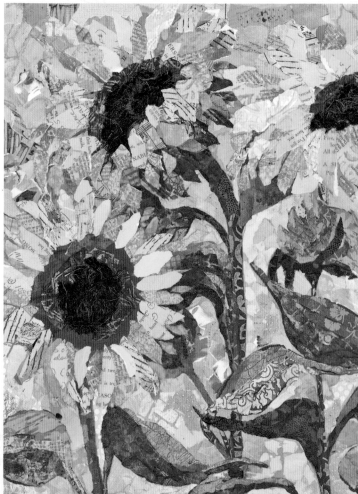

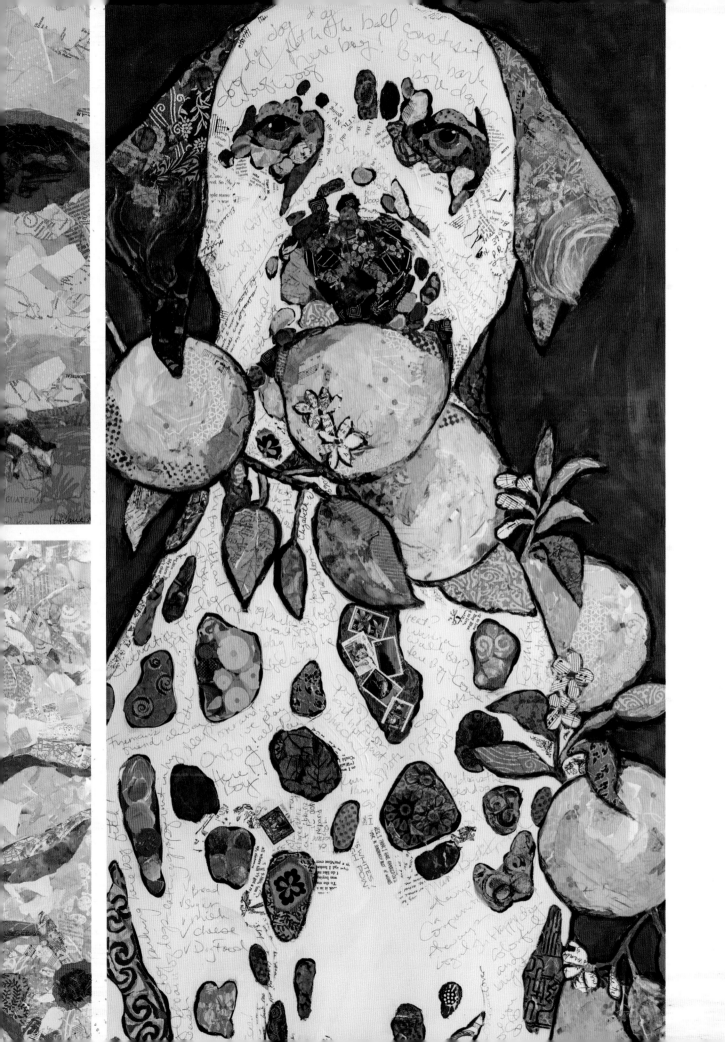

Materials Used in This Book

DON'T FEEL LIKE YOU NEED to have all of these products in order to start painting and creating. Begin with the techniques that require materials you already have or the basic necessities: paint, paper and brushes or other application tools. Then as you progress through the book, add a few new tools and materials as they strike your fancy. Pretty soon you will know what suits you and where your passions lie, and you'll have the tools and materials you need to follow your paper painting dreams.

PAINT, GLUE, GELS

Acrylic paint colors: black, gray, red, orange, yellow, blue, green, white, brown and purple (Fluid acrylics are necessary for the paper painting techniques.)

Elmer's glue

Gesso

Gloss gel medium

Golden UVLS acrylic varnish

Liquitex clear gesso

Liquitex gloss gel medium

White gesso

PAPER SUPPLIES

Corrugated cardboard

Decorative paper from art supply stores (lightest colors available)

Dry waxed deli paper

Found paper including pages from atlases, catalogs children's and adult books, Chinese (foreign language) newspapers, gift tissues, handwritten notes, kids' old homework, maps, sheet music, wallpaper samples, etc.

Palette paper pad, 12" × 16" (31cm × 41cm)

Paper doilies

Rice and translucent papers

WRITING SUPPLIES & PAINTBRUSHES

Crayons

Derwent Inktense pencils

Faber-Castell Pitt Pen

Pencil (graphite)

Paintbrushes

- Filbert-style small and medium for glue and underpainting
- Winsor & Newton's Artists' Acrylic brushes for painting

Prismacolor sticks

Rollerball paint pen

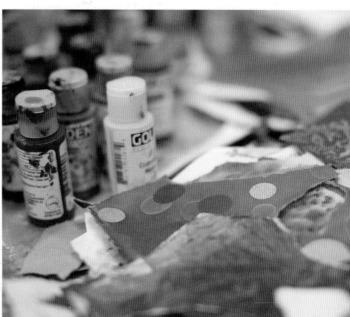

MATS

Craft mat
Nonslip rug liner, place mat or other
 textured material
Silicone place mat
Silicone sink liner

OTHER MISCELLANEOUS SUPPLIES

Archival ink pad (optional)
Brayer
Brush cleaner (Masters)
Bubble wrap
Craft fun foam (self-adhesive)
Eye dropper
Gallon zip bags for organizing papers
Gelli Arts printing plate
Hair dryer (optional)
Hand-carved stamps
Hot glue gun and glue sticks
Isopropyl rubbing alcohol
Liquid dish soap
Paper towels
Parchment paper
Plastic card (like a room key or gift card)
Rolling pin
Sea sponge
Shoes with pattern on soles
Speedball linoleum cutters
Speedy-Carve carving material and tools
Spray bottle/mister
Stencils
Texture plates or other textured surfaces
Tile (glass, ceramic or terra cotta)
Toothbrush
Vessel for water
Waxed paper plates for palette

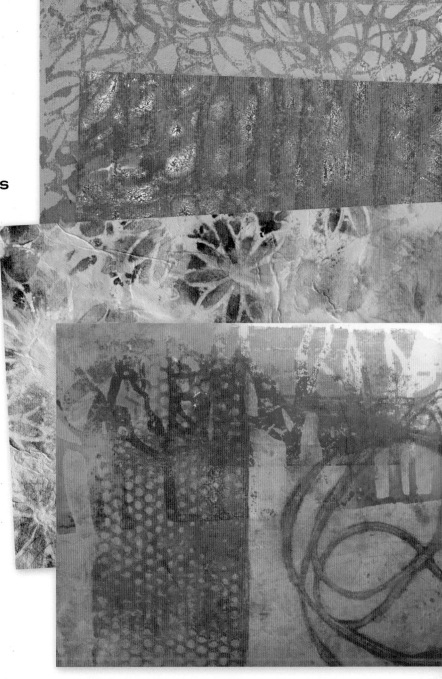

What sets the collage work of Elizabeth St. Hilaire apart is
her use of unique papers. Her signature collage style utilizes
papers colored by hand in every hue and texture needed for a
complete paper palette. Only professional artists' colors are
used for the underpainting and paper painting. Professional
acrylic paints are fade resistant and archival. Finished collages
are coated with ultraviolet light stabilizing varnish for a final
protective layer that eliminates the need for glass.

Foreword

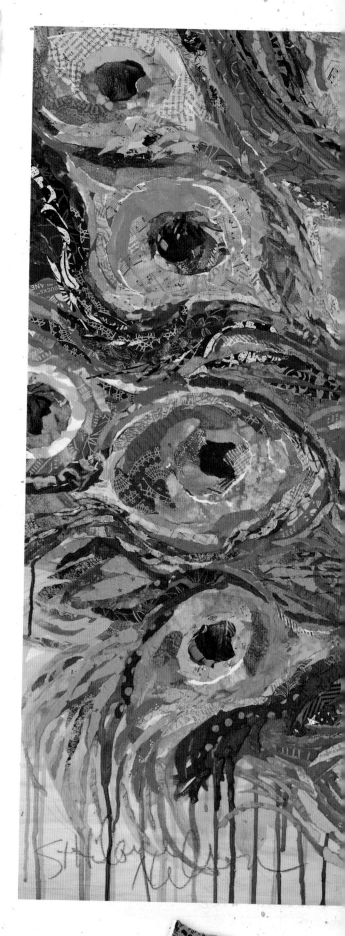

ONCE IN A GREAT WHILE an artist comes along whose work is so distinctive, so unusual, so imaginative and so colorful that it stands out from the crowd, much like a peacock stands out in a colony of penguins. Elizabeth St. Hilaire is such an artist.

I have seen thousands of works of art over the years—in galleries, museums, art shows, hotels and in private collectors' homes—but I've never seen art like Elizabeth's. Who else creates such fabulous flamingoes, pretty pigs, darling donkeys, colorful koi, delightful Dalmatians and charming chickens—all out of bits of torn painted paper? No one. Elizabeth is one-of-a-kind. Her work, both in style and method, is uniquely hers.

It was her signature bird—the peacock—that first caught my eye. A friend on Facebook had posted a fabulous image of *Peter Peacock*, a large collage painting on display in a gallery in Sedona, Arizona. (I've been attracted to peacocks since the publication of my very first book some twenty years ago—it was about peacocks and penguins. Since then, the peacock has been my spirit bird, my personal totem.) I'd never seen a peacock quite like the one that Beth created with paint and collage. *Peter Peacock* stole my heart!

I had to learn more about the fabulous artist who could create such a powerful peacock image, so I tracked down her website, friended her on Facebook and began collecting her work. It was the beginning of a lovely friendship.

In addition to painting and collaging, Beth teaches workshops and writes books for people who want to learn her technique. She generously shares her creative secrets with all who want to learn them. She explains her process step-by-step, clearly and succinctly. She is more than a great artist—she is a great teacher. She helps unleash the latent talent in her students. She coaches; she trains the eye as well as the hand; she inspires others to express their own creative impulses.

In this wonderful new book Beth shares the tips and tools of painted-paper collage making. If her unique technique appeals to you as much as it does to me, here's your chance to learn it and make it your own.

Read it and reap … great results!

BJ Gallagher
Author of *A Peacock in the Land of Penguins*

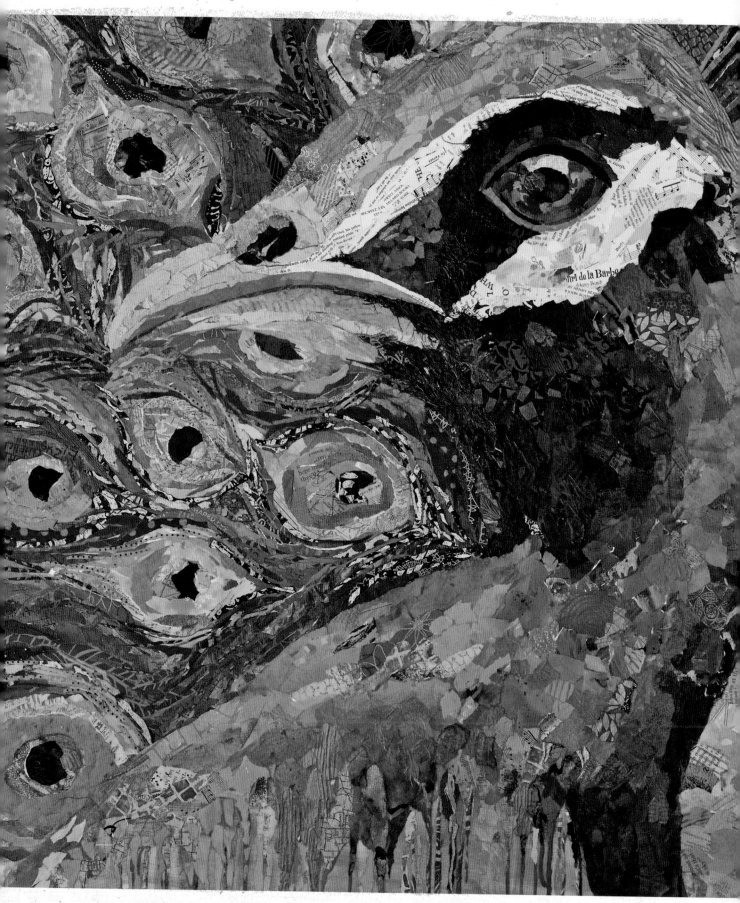

PETER PEACOCK
Collage of hand-painted paper on wood panel

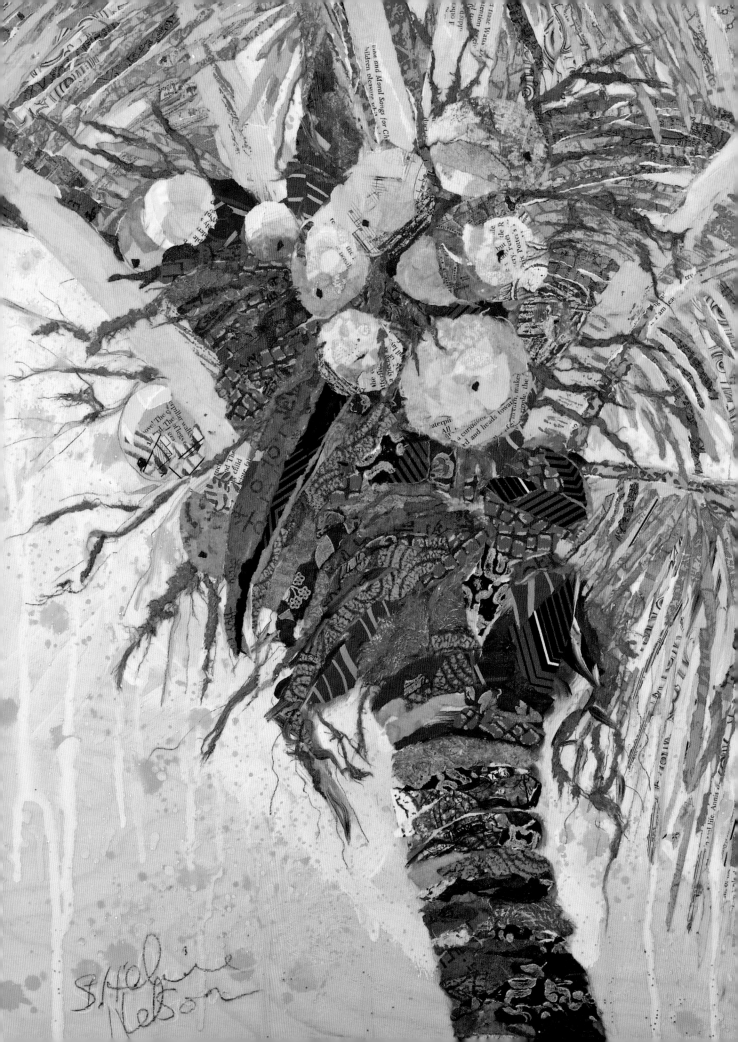

Introduction

IN THE LAST NINE YEARS my collage technique has evolved from that of purchased decorative papers to one of hand-painted art papers. The decision to paint my own papers was out of a concern for fading. Decorative papers (colored with dye rather than pigment) were fading and changing color in a way that concerned me in regard to the integrity of my artwork. After thinking more about this dilemma, I made the decision to work only with papers that I painted myself. In my collage process I would use only professional artists' acrylic colors and UV protective varnish. It seemed to me that papers painted with pigment would outlast commercial dyed papers. What I would realize later is that they would outshine them as well.

Hand-painted papers became the foundation of my collage process, and they elevated my work to the next level. Now that I was creating my own paper palette, I had more control over the colors and shades of colors that I had at hand. In addition to a full range of values in each color, I began incorporating beautiful textures and patterns into paper painting. Eventually I created a full inventory of exquisite hand-painted papers that far exceeded what I ever was able to obtain at my local art store. Stamping, Gelli printing, texture rubbing, crayon resist, scraping, scumbling, monoprinting, stencilling, stippling, dripping, combing, mark making and handwriting were just a few of the techniques I used to embellish both purchased art paper as well as found papers such as old book pages, catalogs, maps and even the kids' homework. Nothing was off limits when I set up the studio for painting paper.

The techniques I use for painting paper are ones I have perfected over years of teaching and experimenting in the studio and the classroom. Some techniques were originally happy accidents and some techniques I learned from my students. This book gives detailed examples of the most successful and popular of them all.

Hand-painted paper is not just for collage; it can serve as the background for a personal art journal, the base of a scrapbook page, gift wrap, gift tags, handmade note cards, party decorations, place cards, mobiles, artist trading cards—you name it. Not to mention that the process of painting paper is something my students say they could do all day long. It's just that much fun.

It is my hope that you will experiment with all of the techniques in this book before you pick your favorites. The effects I get with some of my classroom demonstration papers make the students ooh and aah, but they don't necessarily always find them to be the techniques they choose to use themselves. Why not invite some friends to join you? Spread out your materials on a big table and have fun painting papers together. Then swap and trade and expand your inventory with the styles and color palettes of fellow paper painters. I've gotten some amazing papers in trade that I would have never made on my own.

Elizabeth St. Hilaire

KEY WEST PALMS
Collage of hand-painted paper
with acrylic on wood panel

"My technique has evolved and changed as a result of experimentation with hand-painted, handmade and textured or patterned papers. Layering and weaving, pushing and pulling the colors, patterns and values make the collage process resemble a dance—undulating, alternating and overlapping, until the rhythm creates something I love. In my work I highlight the extraordinary within the ordinary, focusing on intense and vibrant colors combined with a sensibility of design. My collages invite the viewer to look, and having looked, to linger."

Getting Started

IN MY STUDIO AND IN MY TRAVEL SETUP I organize my hand-painted papers by color. It is imperative to work by color because when you are in the heat of the collage process, you want to be able to work fast, stay loose and keep moving. If you can dig through the "red drawer" or the "red bag" versus a multicolored heap, you will find all of the above much easier to achieve. I tell my students, "You can never have enough paper." This is something I say over and over again in class. The very best way to take advantage of an abundance of shades and techniques within one color is to have it all at hand in one place. To this day, when I dig down to the bottom of the red drawer, I find papers that I have not used in a while because I tend to stay to the top layer. Knowing this, every now and then I flip the contents of my drawers upside down, bringing the papers from the bottom up to the top, making them new again.

PAINTED BUNTING
Collage of hand-painted paper, acrylic and pencil on wood panel

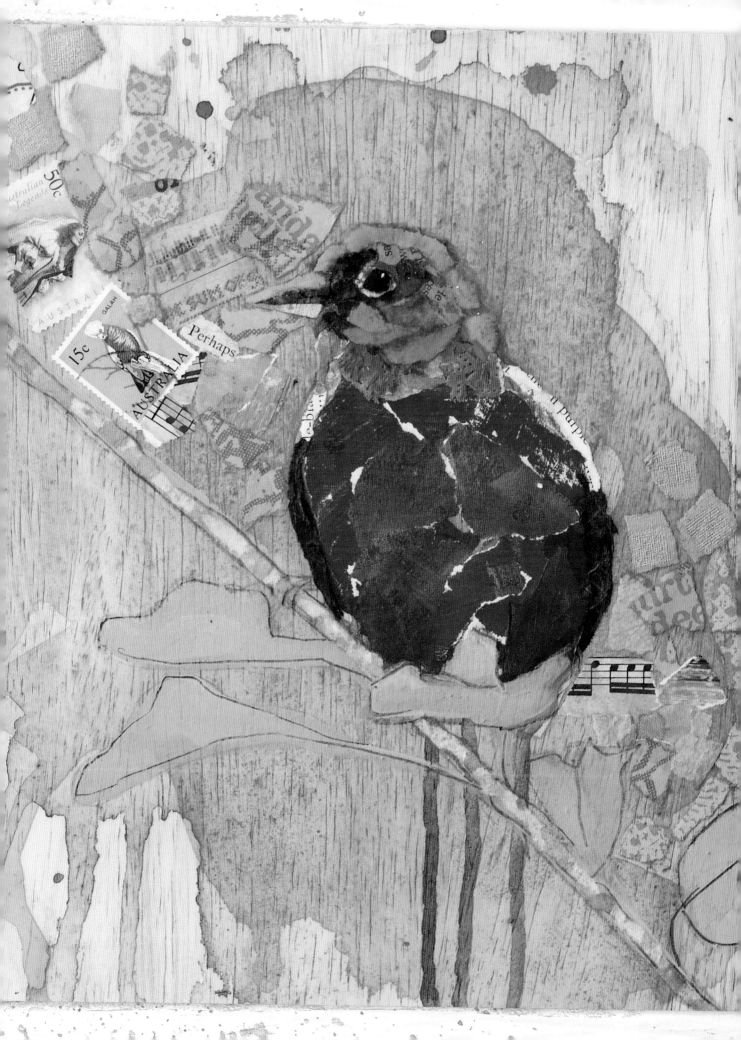

Paths

I PREFER TO USE GOLDEN FLUID ACRYLIC COLORS to paint my papers. These paints are lightfast, durable and flexible. They are wonderfully versatile, professional-quality acrylic colors with the consistency of heavy cream. Highly pigmented, their excellent tinting strength produces strong color even when mixed with acrylic medium or when thinned with water for staining effects on book pages and memorabilia that you want to tint but not obscure.

Another brand I like is Nova Color (based in Culver City, California). I have visited the factory store and the paints are very high quality. Nova Color caters to mural painters, so you can get your favorite colors in quantities from a small container all the way up to a gallon. Visit them online and request a color swatch chart for accurate color representation: novacolorpaint.com

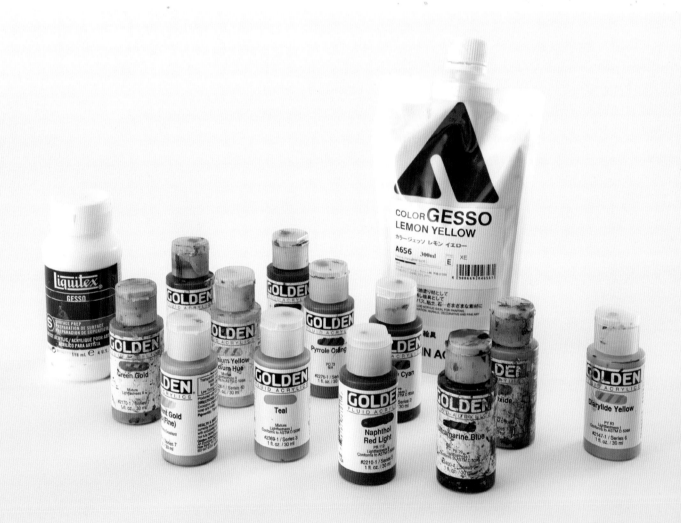

Purchased and Decorative Papers

I LOVE DECORATIVE PAPER from art supply stores. I just don't buy it precolored anymore if I can help it. I try to go for the lightest color I can get, and then I paint it. There's still a lot to be said, after all, for the texture, gold foil or iridescent patterning, flecks and specs, glitter, embossing and silk screening that often are a part of commercial decorative papers.

Whenever I teach or travel out of town, I always find the local art supply store and check out their paper selection. As a result, folks in my workshops ask, "And where did you find *that* paper?" I usually don't have an answer. Clearly, I picked it up somewhere along the way, but I can never quite remember where.

I also tend to stockpile paper when I can and paint it later. I love to collect papers for a future studio painting or class demonstration opportunity. And as much as I like the convenience of online shopping, there is something to be said for touching, feeling and handling a paper; you learn so much about the properties of paper in person, so please make this a part of your routine.

Found Papers and Personal Ephemera

FOUND PAPERS are the papers you come across in your day-to-day activities: sheet music, maps, wallpaper, handwritten notes, old book pages, handmade papers, deli paper, gift tissue in a variety of thicknesses and textures to name a few.

I have enjoyed rescuing out-of-date wallpaper books from Home Depot, and I always ask for an extra sheet or two of tissue paper when I visit Anthropologie (a chain of stores that sell women's clothing, accessories, gifts and home décor). My barista is always willing to give me a brown craft bag (the large one, please) whenever I go for coffee, and the waitress at the country club gladly brought me paper doilies of all sizes when I told her that I would use them in art. When my children were in elementary school many years ago, the librarian sent home piles of books that had been taken out of circulation because of broken spines or wear and tear. I still work from this inventory, despite my children being in high school.

Do not pass up any opportunity to put interesting papers in the painting queue. Stash them for later, collect them everywhere you go. You can never have enough paper. You'll hear me say that all day long in my workshops.

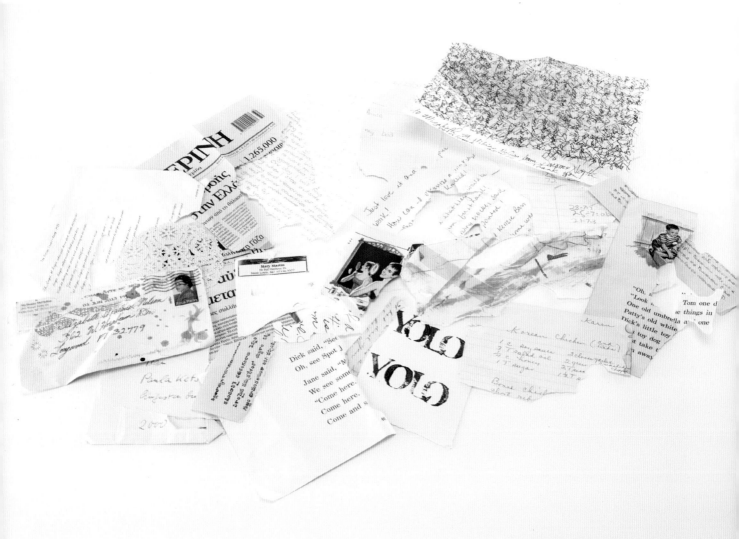

Vintage Papers

ANOTHER WONDERFUL SOURCE of vintage books, maps
and ephemera is eBay. I have bought many books of sheet
music and old atlases on eBay, right from the comfort of
my living room. Some folks love to hit up the yard sales
and visit flea markets, and that can be a wonderful way to
pick up vintage papers as well. My father gave me papers
from my childhood that my mother had saved through the
years. You may have a box of such papers of your own, or
just ask your mom.

Old sewing patterns can be fun to work with; the beige
pattern tissue makes for some wonderful translucent
overlaying material in the collage process.

Do you have vintage love letters from grandparents or
have you found them at estate sales? Handwriting is an
amazing addition to collage. Every person's handwriting is
unique and different; this adds yet another personal touch
and artistic dimension to your collage work.

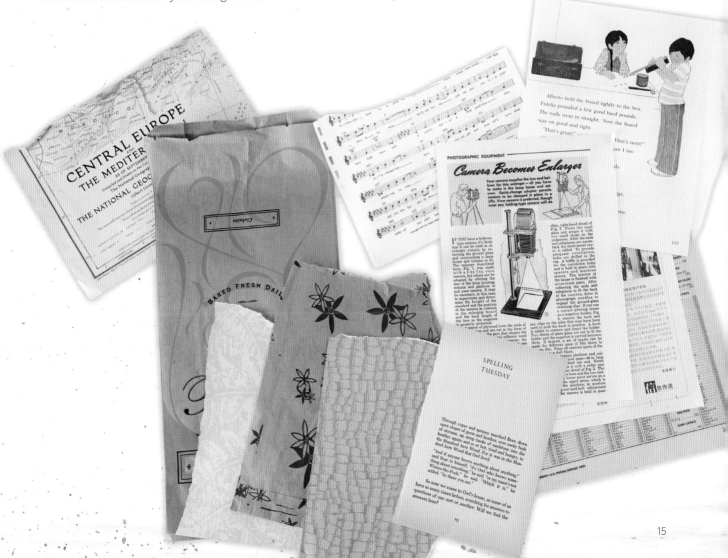

Rice and Translucent Papers

These acid-free Oriental rice papers are strong and absorbent. They are made in the centuries-old Japanese tradition. With their white and natural tones, they make an excellent base for creating your own brilliantly colored collage papers.

- *Hosho*—*Hosho* is a traditional *kozo* (mulberry fiber) paper that doesn't shrink or tear easily, making it ideal for woodblock and lino printing. *Hosho* paper is sized.
- *Kozo*—*Kozo* rice paper is highly absorbent, making it ideal for calligraphy and fluid acrylic painting. *Kozo* paper is not sized.
- *Unryu*—*Unryu* rice paper has been used for centuries in Japan for creating *shoji* screens and is extremely strong, thanks to molded-in fibers. It's excellent for calligraphy, sumi-e and fluid acrylics. *Unryu* paper is not sized.

- *Hanshi*—*Hanshi* Japanese rice paper for brush writing or calligraphy is mould-made in the centuries-old Japanese tradition. It makes an excellent base for fluid acrylics and is available in sheets, if you prefer, versus a roll.
- Assorted Japanese sheets—You can purchase a ten-sheet assortment of fine Japanese papers from dickblick.com. The assortment includes two full sheets each of *kinwashi* (sized), *okawara* (sized), unryu (not sized), *kitakata* (sized) and mulberry (not sized). It's a nice way to experiment and find which papers work best for you.
- Thai *unryu*—Long, swirling strands of *kozo* provide contrast and texture in these traditional-style *unryu* papers. Lightweight and translucent, the papers come in a range of natural tones, perfect for painting your own colors, textures and patterns.

WHY AM I WILD ABOUT RICE PAPER?

Rice paper accepts paint beautifully and absorbs watered-down pigment all the way through. This quality in rice paper also means that when you tear it, if the center of the paper is colored, you won't have white edges. White edges can be distracting, particularly in dark papers where the contrast is high, as they visually outline every torn shape. White edges within a yellow area are low contrast and not super distracting, but white edges around every torn tidbit of navy blue or black paper would be very busy and distracting. There are tearing techniques to avoid white edges in nonabsorbent papers; rice paper just makes an easier job of the process.

Another wonderful aspect of the color soaking all the way through rice paper is that what happens on the back side can be more interesting than what you were focused on creating on the front.

Other Materials and Supplies

- A variety of papers: sheet music, maps, wallpaper, handwritten notes, old book pages, handmade papers, deli paper, white tissue—all in a variety of thicknesses and textures. You can absolutely use found papers.

- Decorative papers: papers you purchase at your local art supply store that have fibers, embossing, metallic patterning, iridescent patterning—whatever catches your eye. Please purchase these in white or natural if possible; this allows for the most color options when painting.

- White gesso for resist techniques: White gesso can be used with stamps and mixed with paints to add an opaque quality.

- Supports: ⅛" (3mm) sanded plywood panels, available at Home Depot precut in 24" × 24" (61cm × 61cm) or 24" × 48" (61cm × 122cm) sizes. These can be cut down to smaller sizes by your friendly Home Depot employee [I don't recommend cutting supports any smaller than 12" × 12" (30" × 30")] or cut by you with a little elbow grease and a utility knife with a new blade. This is thin wood—only ⅛" (3mm)—not standard ply.

- You can also use American Easel wood painting panels or Baltic Birch panels. American Easel's wood painting panels are cradled with a solid wood frame that won't flex, stretch or warp. They come in a variety of sizes. Baltic Birch panels are also a popular and affordable option. They are available in a variety of popular sizes, including square sizes, in convenient packs of five panels. Each flat panel measures ⅛" (3mm) thick.

- Brushes: I use and recommend filbert-style paintbrushes in a variety of small and medium sizes for underpainting and applying glue. I use cheap synthetic brushes, use them and abuse them, and then throw them away!

- For painting, I prefer Winsor & Newton's Artists' Acrylic brushes. They are high-quality brushes that you will have for years if you take care of them.

- The Masters Brush Cleaner: Use this to keep brushes soft and clean as well as to extend their lives.

- Vessel for water: Keep your glue brush in the water if you step away from your work; the glue dries fast.

- Paper towels for cleanup: I like Viva brand.

- Paper plates to use as a palette for your paint: The ones I use are coated or waxed; the cheap paper ones are too absorbent.

- Palette paper: A pad of shiny surface palette paper to dry your papers on; they can be reused multiple times.

- Gallon plastic zip bags for organizing papers.

- Glass eyedroppers for dropping rubbing alcohol.

- Gelli Arts printing plates are flexible and easy to use. They look and feel like a gelatin monoprinting plate—yet they're durable, reusable and can be stored at room temperature. They are ideal for mixed-media art, card making, artist trading cards and more. They measure ⅜" thick and are easy to clean with soap and water, hand sanitizer, baby wipes or packing tape, and they come in a variety of sizes [I use the 8" × 10" (20cm × 25cm) plate].

- Speedball Linoleum Cutters and Speedy-Carve carving material.

- Liquitex gloss gel medium, the adhesive glue: A high viscosity medium, it dries to a crystal-clear gloss finish.

- Golden satin varnish for final sealant with UVLS (ultraviolet light stabilizers) is a waterborne acrylic polymer varnish that dries to a protective, flexible, dust-resistant surface.

- Stencils: My favorite stencils are from StencilGirl Products. They are designed by artists, for artists. These Mylar decorative stencils are thick enough to be durable and last through countless projects, but thin enough for a seamless look in your art.

- Spray bottle: I purchase a good-quality Rubbermaid spray bottle at Home Depot so that it will stand up to the test of time; cheap sprayers will eventually have nozzle issues. A tough, durable plastic spray bottle is essential for working in the soap bubble technique.

Storage Solutions and Organizing Paper by Color

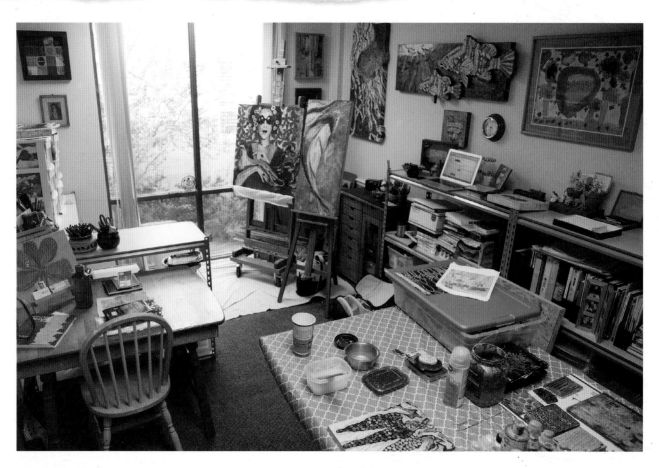

STORAGE SOLUTIONS

If you can afford some space to call your own, it makes all the difference in the world. I am very fortunate to be able to create a mess of torn paper and be able to close the door and walk away when I am done for the day.

In the past I have worked in an extra bedroom and in a corner of the garage. Being creative means having your work accessible at all times so that when inspiration strikes, you can jump right in. You don't need an ultra-fancy space, just a space; I have an artist friend who works in a storage unit!

My favorite studio organization piece is a kitchen cart on wheels. I have three sets of clear plastic drawers stacked on top of the cart so that they are easily accessible while I work at my easel. (I prefer to stand and do my collages rather than sit at a table.)

I divide my hand-painted papers by color family, and the clear plastic allows me to see which colors of paper I have in each drawer. When I know I will be spending significant time on an area of one color, I take that drawer out and put it right next to me.

My second favorite organization system is a clothes-line that runs from one end of my studio to the other. I use wooden pins to put my wet painted papers up to dry. This system works well for keeping paper from sticking to the table or the floor. It also allows for some happy accidents in the drying process when one wet paper touches another, and the color transfers in beautiful and unexpected ways. Synchronicity.

FAQ

What do I do if a paper has two colors from this list on it? I tear it in half and put a piece in both drawers!

ORGANIZING PAPER BY COLOR

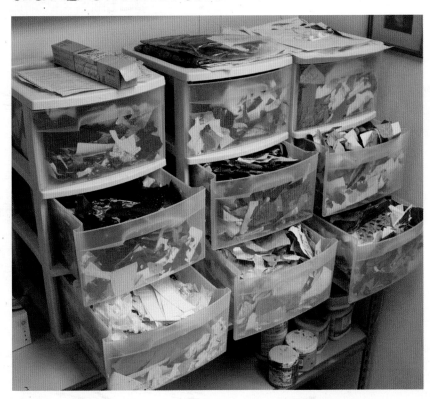

I organize my papers by color, a paper palette of sorts. It is much easier to work the green areas of your collage when your papers are organized enough to let you easily and quickly find the green pile. Rather than digging through a multicolored mess, organization enables efficiency. I file my papers in the following color groups:

- black and gray
- red
- orange
- yellow
- blue
- green
- white
- brown
- purple

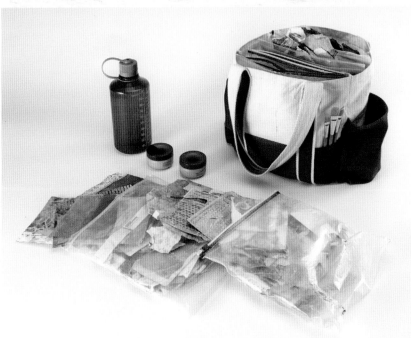

My travel setup consists of gallon-sized plastic bags, each filled with one color of hand-painted paper, stacked into a tote bag with outside pockets for glue, brushes, drawing tools, a water bottle and folded paper towels. Every so often I spill the bags (one at a time) onto a table, eliminate the pieces of paper that are far too small, fold flat the ones that have gotten wrinkled up into a ball and reorganize the colors. When you are working in small spaces, the organization of the colors within the gallon bags is imperative.

Techniques for Hand-painting Paper

EVERY COUPLE OF MONTHS I CLEAR MY WORK TABLE, pull out the paint and paintbrushes, and I make myself a batch of custom-colored collage papers. My friend and fellow collage artist Jo Reimer (check out her work at jreimer. blogspot.com) suggested that I try fluid acrylics since they retain their intensity when watered down. I said to her, "Jo, are they really better? Because they are really expensive." She said "Yes," and I took her advice, and guess what? They are really great! You can dilute fluid acrylics, splatter, splash, blot into them and more, and they stay very intense in their color. The beauty of fluid acrylics versus full-body tube paints is that every subsequent layer multiplies with the one below it, creating rich and deep beautiful layers.

Beyond just tinting collage papers with fluid acrylics, I have developed some interesting techniques for adding pattern and texture. I splatter, drybrush and monoprint with a Gelli Arts printing plate. I carve my own stamps, I use sink liners and nonskid rug liners. I've marveled at the effects of rubbing alcohol, soap bubble spray and kosher salt on the paint and the paper that it adorns. Nothing is off limits when it comes to creativity and painting paper, and experimentation is key.

NAOMI POPPIES
Collage of hand-painted paper with acrylic and colored pencil on wood panel

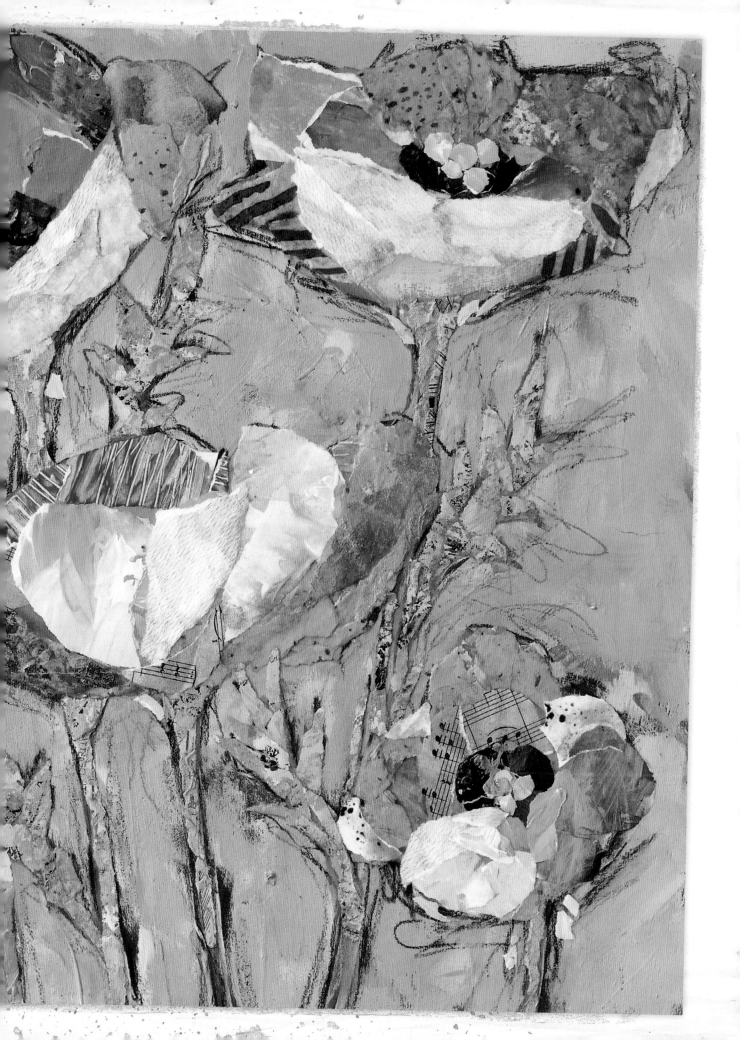

Additive, Subtractive and Resist Techniques

ADDITIVE TECHNIQUES are any that involve adding paint to paper. You'll learn how to add paint to paper with hand-carved stamps, bath and place mat transfers, stencilling, splattering and more. The combination of additive techniques layered together is key! You'll be amazed at the results.

Conversely, subtractive techniques involve the removal of paint from your paper. Many of the same tools we use to put paint on the paper can also be used to remove it from the paper. Subtracting paint from paper can yield as interesting effects as adding it. Scraping, scratching, sanding, stamping, and pressing can all remove paint from paper in interesting and creative ways. As always, experimentation is key.

Resist techniques are a whole other animal and involve pushing paint away from a resist medium. Some of these techniques, especially crayon resist, remind me of coloring Easter eggs as a child. My goal was always to make my eggs the most elaborate in the basket. With resist techniques, timing and paint viscosity are key and so experimentation is imperative. Overlay one or various resists multiple times for unique effects. Fluid acrylics work best with overlay, since they are translucent.

A clean work surface, clean water for rinsing brushes, paper towels, a creative work space and some good music are also imperative to your success and enjoyment, so don't overlook or discount any of them. Once a paper has been painted, moving it out of your work area can mean putting it outside on the grass to dry, moving it to a plastic tarp or hanging it on a clothesline (inside or out).

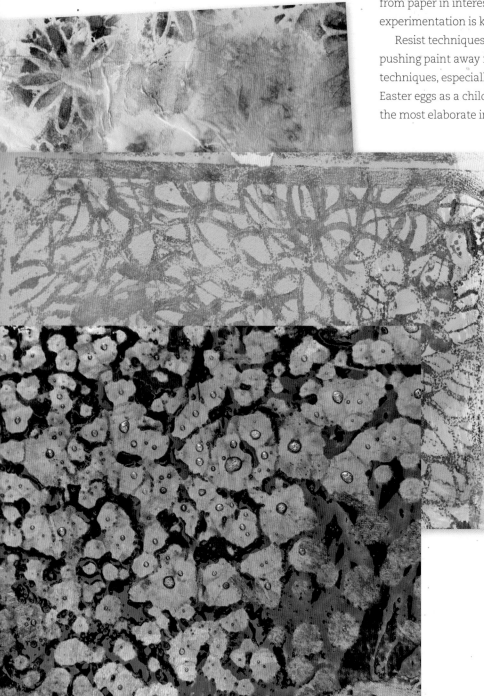

Craft Foam Stamps

CRAFT FUN FOAM can be found in the kids section of your local craft store. This material is easy to cut with scissors or a mat knife and is self adhesive.

HOW TO MAKE CRAFT FOAM STAMPS

Cut the craft foam sheet in half. Use one half as a base and cut the other half into pieces with scissors, a craft knife or decorative-edged scissors.

Peel the self-adhesive backing paper off the patterned pieces and press them onto the foam base or cardboard to secure.

MATERIALS LIST

brayer

cardboard (optional)

craft foam
(self-adhesive)

fluid acrylic paint

rice paper

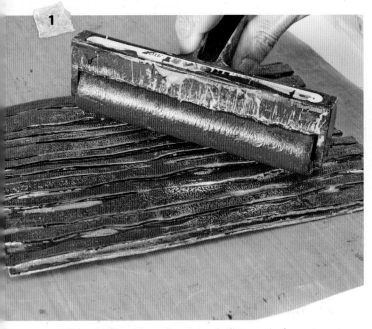

1. Coat a brayer with acrylic paint and roll it over the foam stamp in an even layer.

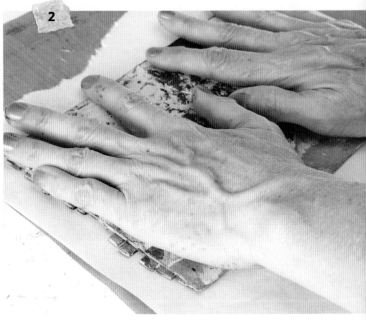

2. Press your stamp onto the paper, rubbing with your hands for a good impression.

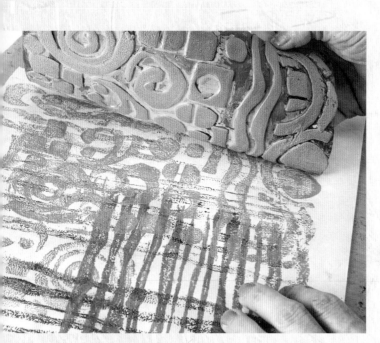

ADD DEPTH BY ADDING LAYERS AND MIXING PATTERNS

By introducing a new stamp to the paper you are creating, you will not only add layers but also dimension. As you did with your first stamp design, add one color to one direction of the paper. Then rotate the paper and brayer on a new color of paint for a new layer. Fluid acrylics ensure that each layer shows through the next.

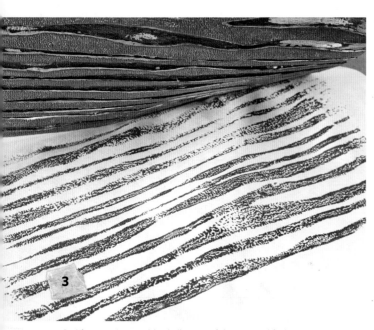

3. After you have rubbed all areas of the stamp, lift the stamp off the rice paper.

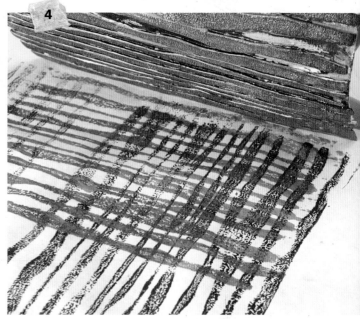

4. Repeat the process with different colors in different directions on the paper. This particular stamp gives a woven look when it is overlapped with a different layer of color.

ADDITIVE PAINTING TECHNIQUE

Stamp Carving

CARVING YOUR OWN STAMPS can be addictive. With the invention of softer carving materials than in the days of wood or linoleum, you can carve curved and smooth lines with barely any resistance. I can spend hours at the kitchen table or in front of the TV at night carving stamps. I usually purchase an 8" × 10" (20cm × 25cm) sheet of carving material and cut it with scissors to divide it into multiple different-shaped sections. And here's a tip for you: I put a towel on my lap to catch all the shavings when I carve while sitting on the couch.

MATERIALS LIST

- acrylic paint
- archival ink pad (optional)
- brayer
- carving material
- carving tools
- pen or pencil
- rice paper

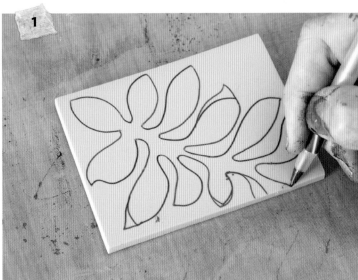

1. Use a ballpoint pen or pencil to sketch your design onto an appropriately sized piece of carving material.

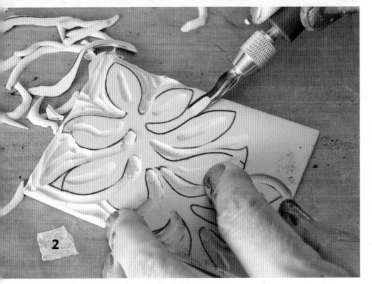

2. Once you have a plan, you can go ahead and carve through the material with your carving tools. Change the nib on the handle for thicker or thinner lines in your stamp. Carve out positive or negative spaces in your stamp. (Carve away the background to leave a positive print design; carve away the pattern to leave a negative print design.)

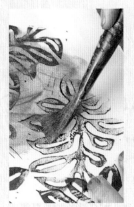

TONING DOWN AND ADDING DEPTH TO YOUR STAMPED IMAGES

Once the stamped impressions are dry, try adding a wash of color to your paper to tone down any white areas.

25

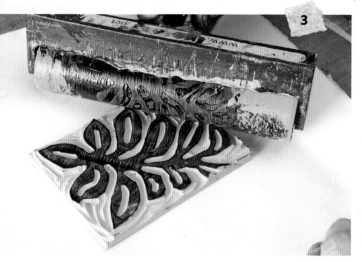

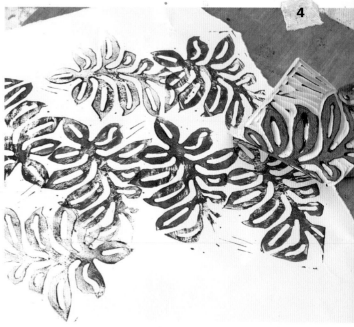

3. Use an archival ink pad or coat your stamp with acrylic paint using a brayer.

ADD MORE LAYERS BY INTRODUCING ANOTHER STAMP

Layering one stamp over itself is a great look, but don't discount the visual interest that comes from layering with multiple stamps.

4. Cover your paper with overlapping stamped images. Make impressions in multiple colors, if desired.

STAMP CARVING TIPS

- Readycut carving material (a Dick Blick product) is economical and high quality. Readycut is created by fusing a thin layer of a traditional gray carving block to a thicker white block. This allows you to carve away the gray layer to reveal the white so you will instantly see how your image will look printed.

- Readycut eliminates the repetitive inking, proofing and cleaning sometimes necessary in stamp carving because adjustments and additions are easy to see in the contrast between the gray and white layers.

- Speedball offers a flexible pink eraser-like carving block called Speedy-Carve that is flexible and durable and won't crack, crumble or break. You can also transfer images from inkjet printers onto it to give yourself an easy-to-follow carving pattern.

- Companies such as Ranger offer stamp pads that are permanent and fade proof. You can use these for your paper painting, or you can use acrylic paint; the effects are different, and the choice is yours.

- Once armed with a few different hand-carved stamps, you are ready to stamp on paper. Stamping is just one of the techniques you will use in creating hand-painted papers. The idea is to take one sheet of paper through multiple techniques, adding layer upon layer of texture and pattern. This multipass process is what makes your papers rich and painterly.

- Using your archival ink pad or painting your stamp with acrylic paint, make impressions in multiple colors, overlapping the images over the surface of a white sheet of rice paper or a printed piece of found paper. Once the stamped impressions dry, try adding a wash of color over them to tone down the white areas of the base paper. Colors next to each other (analogous) on the color wheel offer harmonious effects, while complementary colors (those across from each other on the color wheel) offer more intense and color-vibrating effects. Both are effective.

Fondant or Fun Foam Rolling Pin

FONDANT ROLLING PINS add pattern to cake frosting. They also make wonderful patterning materials for painting paper. You can purchase them online or in the cake decorating section of your local craft store. You can also make your own patterned rolling pin by cutting and sticking on fun foam shapes; this is a nice option because the design will be completely original.

CREATING YOUR STAMP-COVERED ROLLING PIN

To create your stamp-covered rolling pin, cut fun shapes out of the craft foam. Peel the self-adhesive backing from the foam shapes and stick the foam directly onto a rolling pin in a pattern or series of patterns that pleases you. You can roll the pin on paper or a Gelli Arts printing plate.

MATERIALS LIST

acrylic paint

Gelli Arts printing plate (optional)

rice paper

rolling pin for fondant or other textured decorative rolling pin (or create your own decorative rolling pin by sticking craft-foam shapes to a regular rolling pin.)

scrap paper

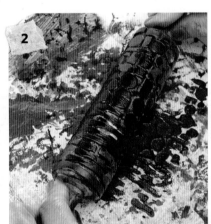

1. Paint your paper if desired. If you do paint your paper, there is no need to dry it before you continue with this technique. In fact, I love the way the paper looks when the layers of wet paint meld together.

2. Coat the rolling pin with color and then roll excess paint off. Roll it on a scrap paper that you can use as collage paper later on.

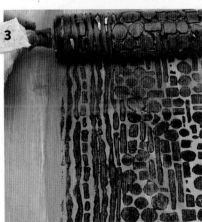

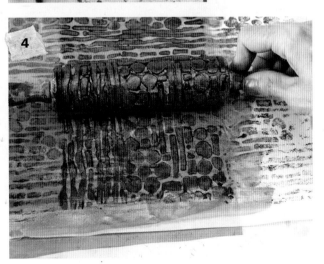

3. Roll the pin over your paper. You could also roll it onto a Gelli plate and print patterned paper from that.

4. Repeat steps 2 and 3, overlapping layers of different paint colors. Trying rolling on paint in opposing directions as well.

Plastic Card Scraping

THIS TECHNIQUE WORKS WONDERFULLY ON DELI PAPER (the dry waxed type). I used to be able to get this paper in my local Costco but have recently resorted to Amazon for a brand called Dixie Kabnet Wax. Be sure to purchase the dry waxed version; it takes paint better. Deli paper has the translucency of tissue paper, but it's much stronger and can take more scraping and stamping than tissue. It's a great paper for beginners.

MATERIALS LIST

- acrylic paint
- dry waxed deli paper
- plastic card
- stencil or texture plate

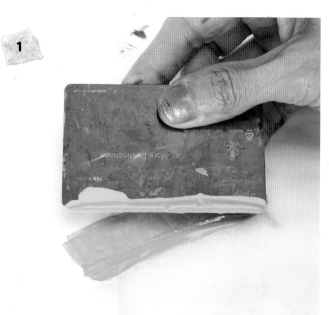

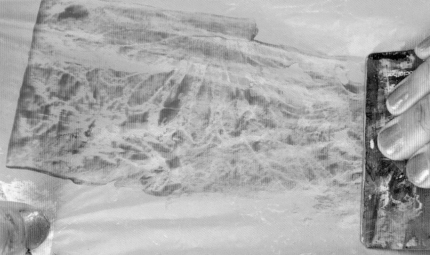

1. Using a plastic card, scrape up a small amount of paint from your palette.

2. Lay a piece of deli paper over a stencil or texture plate. Drag the card across the deli paper, spreading a very thin layer of paint as you go.

3. Keeping the stencil in place, scrape over the paper with a second, darker color. The second pass will highlight the stencil texture in two-tone.

SCRAPING WITHOUT A TEXTURE PLATE

You can also scrape the paint onto deli paper without a texture plate. The result is a bit different but still unique. As you scrape down thin coats of color, overlap and layer them to create blends.

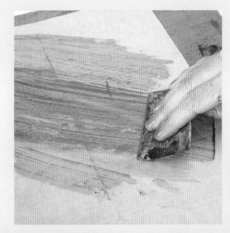
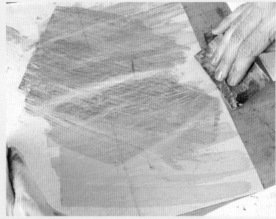
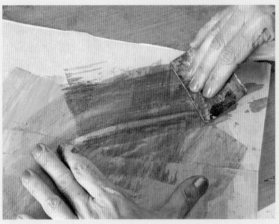
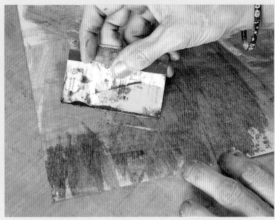

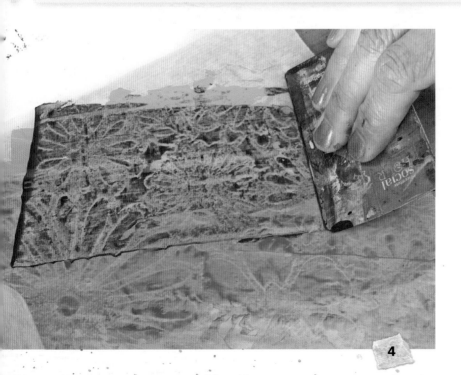

4. Continue to layer both color and texture as desired.

Corrugated Cardboard Stamps

CORRUGATED CARDBOARD is something that arrives at your door on a regular basis if you are an Amazon shopper like I am. If not, you can find free cardboard boxes from your local grocery store or Costco. This technique makes a wonderful second or third pass for your already embellished papers. The corrugated lines are much more organic and nonuniform once the cardboard has been pressed several times; it gets better with age!

MATERIALS LIST

acrylic paint

corrugated cardboard

gesso

paintbrush

paper of any kind

PREPPING YOUR CORRUGATED CARDBOARD STAMP

Tear or cut open a piece of cardboard, separating the layers to reveal the corrugation in the middle.

Coat the corrugated surface with a layer of gesso on both sides and allow it to dry. This prevents absorption of moisture from the paint, which would deteriorate the cardboard before it gained character.

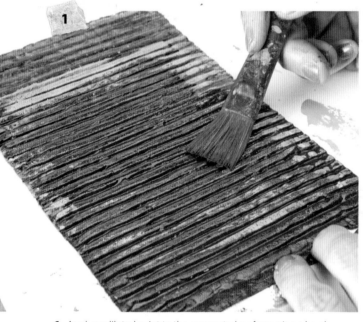

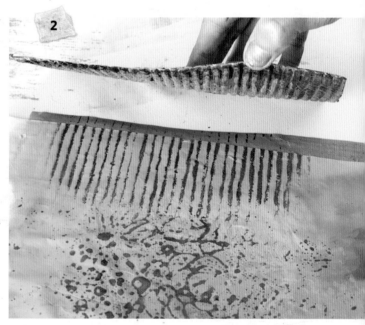

1. Apply undiluted paint to the corrugated surface using a brush.

2. Press the cardboard in either the same or overlapping directions onto any paper surface, experimenting with different types of paper and colors. Here I'm stamping on paper that has already been painted, but you can also stamp on unpainted paper. Again, this is the perfect time to experiment—there is no wrong way to do this.

CONTINUE LAYERING WITH DIFFERENT PAINT COLORS

Working your way around the paper, you can add so much texture by introducing new colors or simply by rotating the corrugated cardboard stamp. Just watch how your cardboard stamp adds character!

As the cardboard degrades from repeated use, the lines become less rigid and more organic, giving the print more character.

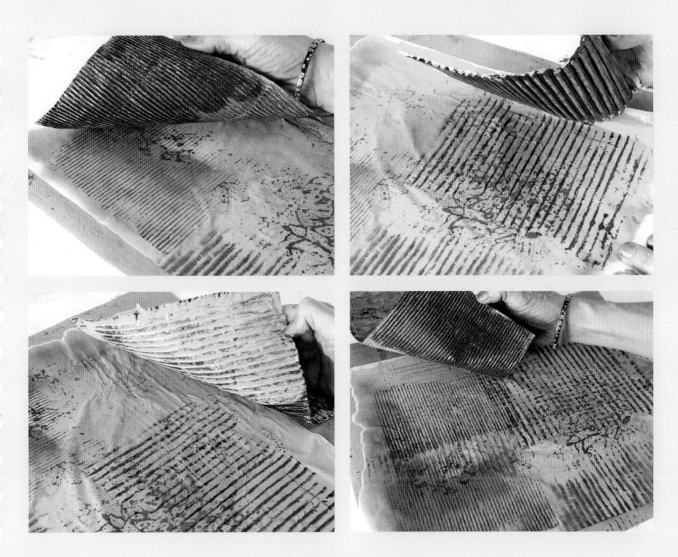

Silicone Sink or Bath Mat

SILICONE MATS MAKE EXCELLENT STAMPING SURFACES. I purchased my favorite sink liner at Lowe's Home Improvement, but you can also find them online at Amazon and at Target. They come in different patterns and textures and their flexibility allows you to make a good connection with the paper when printing.

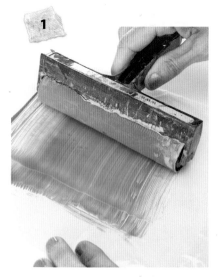

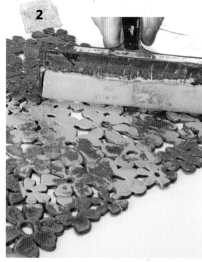

1. Squeeze paint onto a craft mat or other surface and run a brayer through it.

2. Brayer an even layer of paint onto your sink or bath mat to cover the entire surface. You can use one color or multiple colors.

HOW TO CLEAN A BRAYER

The best way to clean a brayer is to roll the paint off on another piece of paper. You can then use that paper in your projects as well. Sometimes that scrap of paper is the best paper of all because you aren't overthinking or stressing over it. I love to run my brayer over the pages of an old book—it's a convenient and interesting surface for the excess paint. Paper towels work, too.

3. Press rice paper (for this technique, I recommend pages from a rice paper sketchpad) onto the sink liner, smoothing it over with your hands to ensure good contact. You want to press the sized, slippery side of the paper into the paint.

4. Pull the paper off the liner and set it aside to dry.

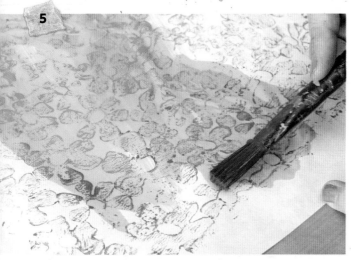

A FEW RIPS AND HOLES ARE NOTHING TO WORRY ABOUT

Depending on the weight of your paper, you might end up with a few holes. That's okay though because you are going to rip the paper into smaller pieces anyway, and you will get a lot of mileage out of a single piece of paper. I usually tear pieces no larger than a half dollar, and individual pieces from the same piece of paper may look completely different depending on where you tear them from; a piece torn from the top left may look completely different than one from the bottom right and so forth.

5. Once your paper is dry, paint a wash over the pattern with a complementary color for high contrast or an analogous color for color harmony. You may want to add water to thin your paint. This works best if the second layer of paint is a wash.

VARIATION 1

In this variation you are layering texture on top of texture. In this case I am using a nonslip rug liner to create an additional layer of texture and I'm using a contrasting color of paint.

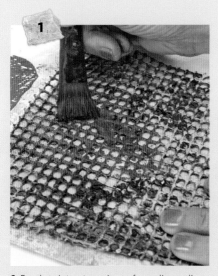

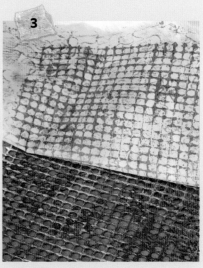

1. Brush paint onto a piece of nonslip rug liner, shelf liner or other flexible textured item.

2. Press dried paper onto the rug liner and press to transfer the paint.

3. Carefully pull the paper off the liner and set it aside to dry.

Silicone Place Mat

SILICONE PLACE MATS ARE SQUISHY and make great stamping material. There are many unique patterns, so be sure to look around. While this technique is similar to the silicone sink or bath mat technique, you can really amp up your papers with the variations shown here.

MATERIALS LIST

- acrylic paint
- craft mat
- paintbrush
- rice paper
- silicone place mat
- spray bottle with water

BASIC TECHNIQUE

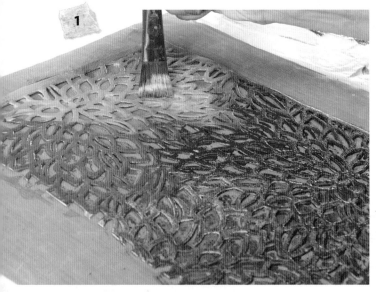

1. Brush paint onto a silicone place mat.

2. Press paper onto the liner, pressing down to make sure you have good contact.

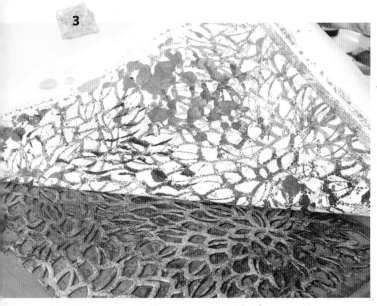

3. Pull the paper back to reveal your print.

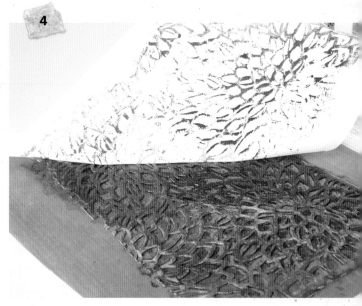

4. Use additional paper to clean up any extra wet paint remaining on the mat.

VARIATIONS 1 AND 2

You can also achieve interesting and varied results by layering paint over (and under!) your transferred place mat design. This is an easy way to diversify your color collections.

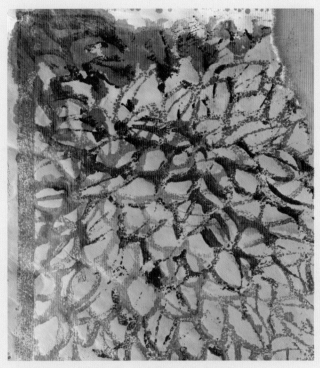

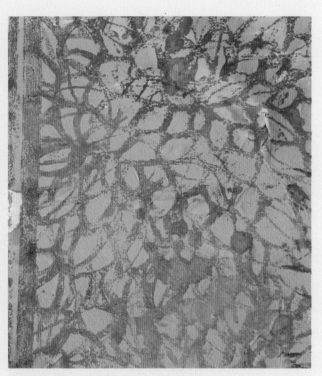

Subtle Differences: Painting the Back of the Paper
Blue paint was brushed on the back side of this paper. The result is like stained glass; the original place mat texture takes center stage and is bright and vibrant against the blue.

Subtle Differences: Painting Over the Texture
This finished paper is more subtle in color. The paint was brushed right over the top of the dried texture, dulling and toning the original paint colors.

WASTE NOT, WANT NOT

Use another paper to clean up the extra paint on the craft mat that was beneath the place mat. This should produce a softer pattern with diffused edges.

VARIATION 3

In this variation you are adding your pattern to pre-painted wet paper. The finish is much more diffused and watercolor-like.

1. Spray water onto your paper.

2. Paint the paper with two layers of watered-down acrylic paint.

3. Brush paint onto the surface of your place mat.

4. Pick up your still-wet paper and place it over the place mat. Use your hand to rub the design into the paper.

5. Lift the paper from the place mat and allow it to dry completely.

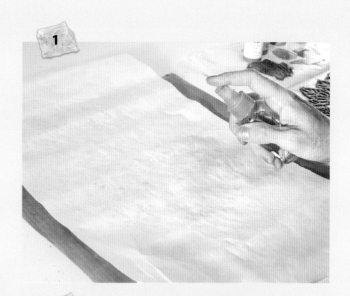

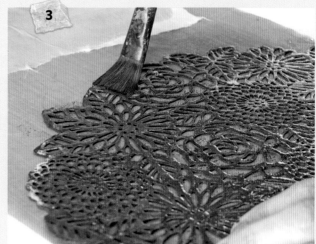

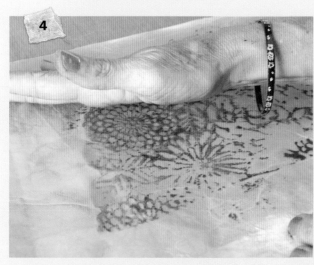

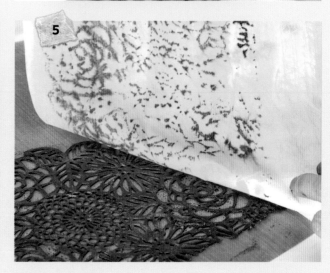

ADDITIVE PAINTING TECHNIQUE
Mosaic Tile Stamps

TILE (GLASS, CERAMIC, TERRA-COTTA) makes a wonderful square pattern impression, be it straightforward, staggered or herringbone. Check out your local home improvement store for a 12" × 12" (31cm × 31cm) sample on a mesh backing. I suggest adhering the tile to a 12" × 12" (31cm × 31cm) wood panel to make it sturdier and easier to move when you are working.

MATERIALS LIST

acrylic paint
brayer
craft mat
rice paper
tile

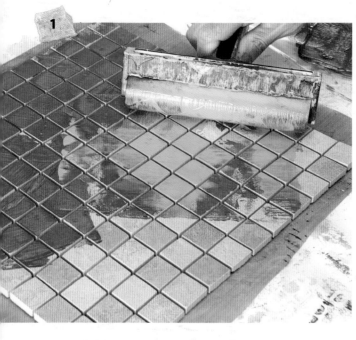

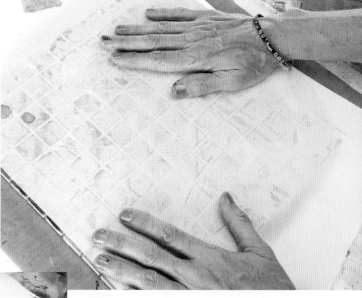

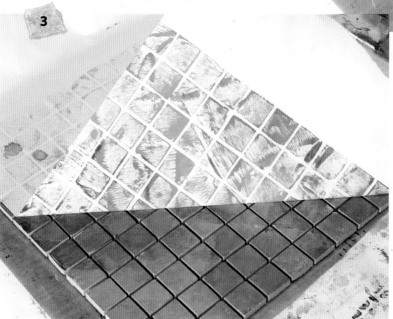

1. Place the tile on a craft mat or other work surface and brayer it with undiluted acrylic paint in either a single color or multiple colors.

2. Press a white rice or light-colored decorative paper onto the tile.

3. Lift the paper from the tile. You can see that the multiple color effect is more vibrant and has a lot of character. A single color effect could be used as a more subdued sheet of paper.

Shoe Print Stamps

SHOES OFTEN HAVE CREATIVE PATTERNS on their soles. You may find a wide variety of soles at your local thrift store or even in your own closet.

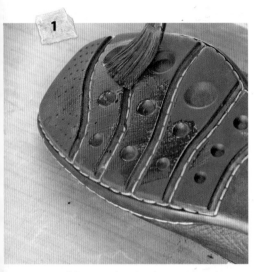

1. Brayer or brush paint over the sole of the shoe, using one color or multiple colors.

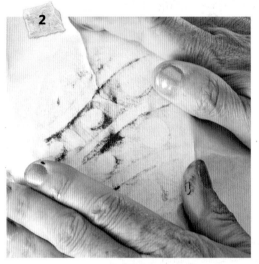

2. Press the paper onto the shoe, making sure to get a good impression.

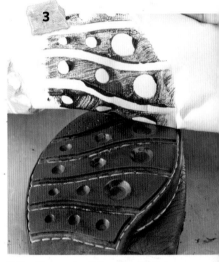

3. Peel the paper off the sole of the shoe.

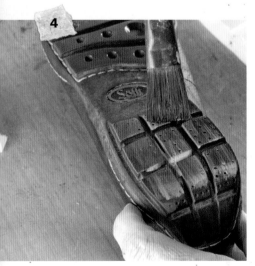

4. You might be able to get several patterns from a single shoe, so feel free to experiment.

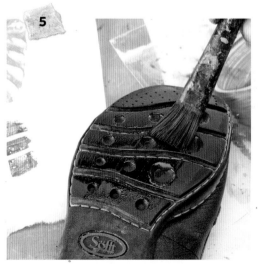

5. Repeat steps 1 through 3 and overlap shoe patterns.

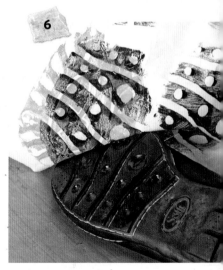

6. Be sure to really press the paper onto the shoe each time to ensure a good impression. Allow the layered patterns to dry.

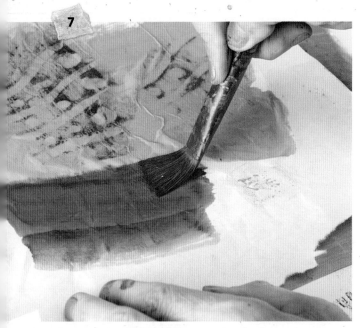

7. Tone down the white areas of the paper with washes of color. This will also tone the paint you stamped onto the paper.

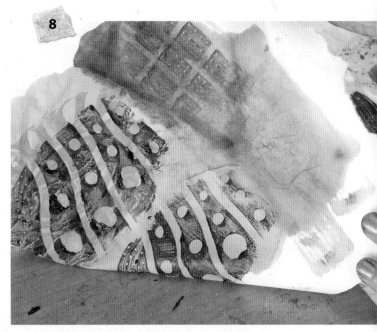

8. If you want the stamped paint to maintain its true color and patterns, try toning from the back side of the paper. The paint will soak all the way through, but the original paint color will pop rather than recede.

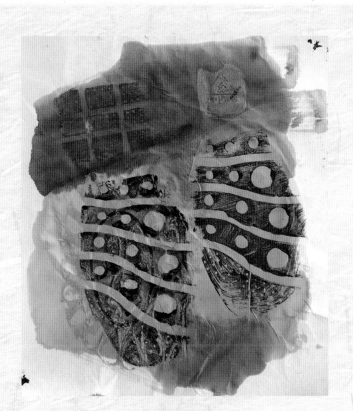

Sample Paper Created with Shoe Print Stamps
Would you have ever guessed that you could create such fun paper using the soles of your shoes as stamps? Crazy, right? Layered, painted, mixed and matched. The possibilities are endless.

Packing Material Stamping

BUBBLE WRAP, both large and small bubbles, offers a nice circular pattern impression when painted and pressed into paper. As you continue to use the same piece of bubble wrap over and over again, you'll notice that some air escapes the bubbles. As you continue to stamp with this deflating bubble wrap, you will see a more organic and less uniform pattern develop.

In this demonstration I am stamping on a variety of painted found papers like book pages and old sheet music.

MATERIALS LIST

acrylic paint

brayer

bubble wrap, packing materials

found paper such as sheet music, Chinese newspapers, children's book pages, phone book pages (toned with acrylic paint if desired)

paintbrush

BASIC TECHNIQUE

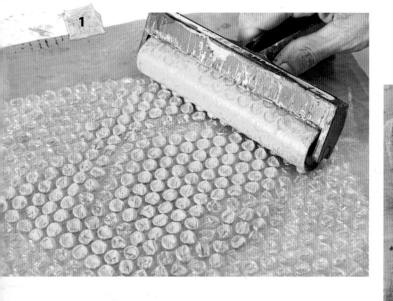

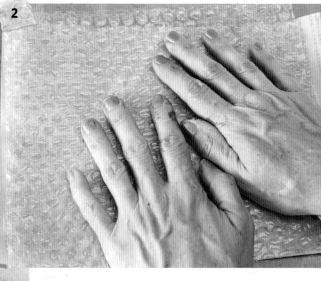

1. Brayer or brush the bubble wrap with undiluted acrylic paint.

2. Press the bubble wrap into a white or printed piece of paper.

3. Lift the bubble wrap from the paper.

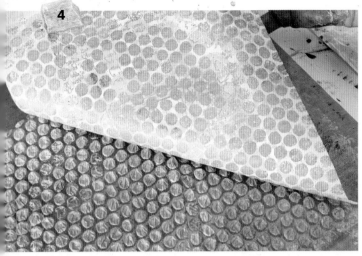

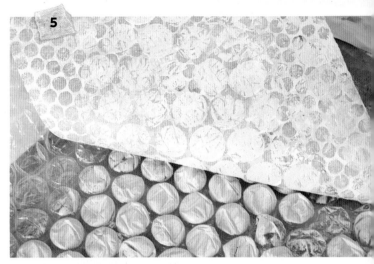

4. Change paint colors and repeat. (I think this technique works really nicely with analogous paint colors.)

5. Continue to overlay the pattern, switching bubble sizes and paint colors for really interesting results.

PACKING MATERIAL STAMPING VARIATIONS

Again the possibilities are virtually endless. Here are just a few ideas to try, from unique bubble wrap patterns to creative layering.

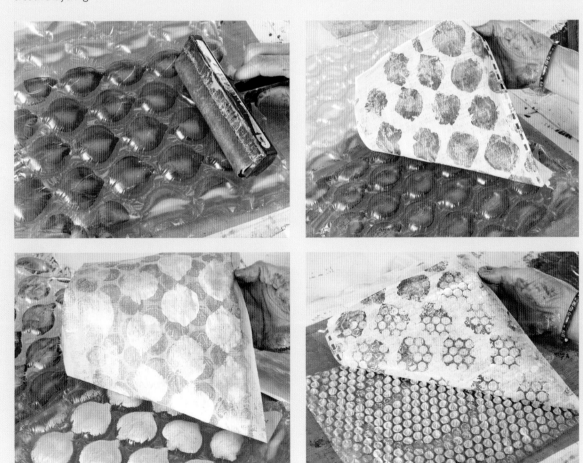

Purchased Stencils

MATERIALS LIST

acrylic paint

paintbrush

rice paper

spray bottle with water

stencil

STENCILS MAKE FOR GREAT ACCENTS on monoprints and gel plates, and they work well with all paints, gesso, inks and sprays. I like painting directly through the stencil onto dry or premoistened paper (spray with a light mist of water from your spray bottle in order to work wet-into-wet) either with a brush or a sea sponge. The stencils used in this demo are from StencilGirl Products (stencilgirlproducts.com).

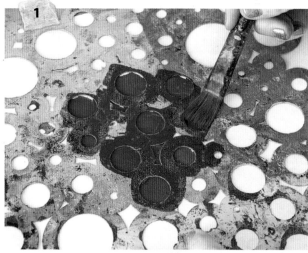

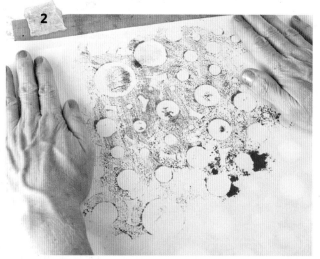

1. Place the stencil on top of a clean sheet of paper. Load your brush with undiluted acrylic paint and paint onto and through the stencil with a single color or multiple colors.

2. Press another piece of paper over the top of the stencil. Press firmly but not too firmly; you want to pick up the paint that is on the negative area of the stencil.

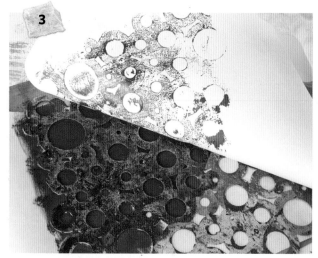

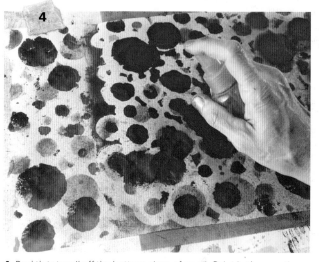

3. Peel the top piece of paper off the stencil. You can use this paper as is or apply a wash to it; use colors close to one another (analogous) on the color wheel for harmony. Use opposite (complementary) colors for vibrant energy. Or apply any of the other techniques we've discussed.

4. Peel the stencil off the bottom piece of paper. Paint in the negative spaces with a wash of a second color, complementary or contrasting or both. Blur the stencil edges by spraying with water. Allow the paper to dry completely.

ADDITIVE PAINTING TECHNIQUE
Paper Doily Stamp

PAPER DOILIES CAN BE PURCHASED IN YOUR LOCAL GROCERY STORE in a variety of lace patterns. Some of the very best paper doilies I have acquired were commercial-grade restaurant-quality ones, simply by asking the server at my local eatery. People love the idea of helping the artistic process; after all, artists are very cool! The minute you tell your barista, Anthropologie employee or food server that you are going to make artwork out of that paper bag, decorative tissue or doily, they are more than willing to give you an extra one or two to go.

MATERIALS LIST

acrylic paint paper doily

paintbrush

rice paper

sponge

spray mist bottle

white gesso

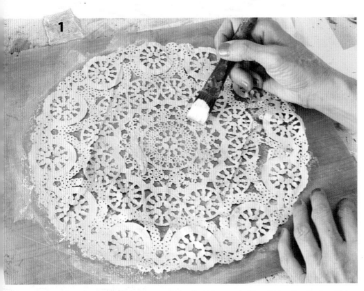

1. Coat a doily with gesso on both sides and allow it to dry. Doing this will protect the doily from excessive moisture, thus extending its life as a stencil.

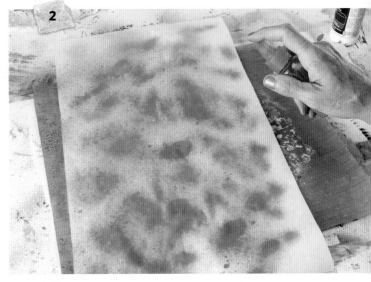

2. Spray mist a sheet of rice paper with a solid wash of light color. Work the next step into the wet sheet of paper or allow it to dry completely. Each yields different results.

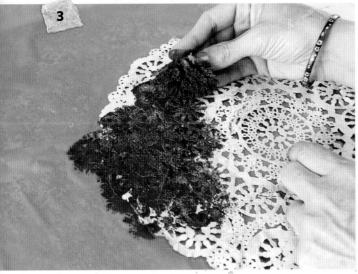

3. Paint a darker color through the doily and onto the sheet of rice paper to make a lacey stencilled pattern.

WET-INTO-WET VERSUS DRY RESULTS

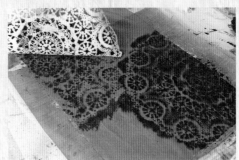

Wet-into-wet will give soft-edged organic results, whereas working dry will yield more crisp pattern edges.

ADDITIVE PAINTING TECHNIQUE
Splattering

SPLATTERING REMAINS THE MOST SIMPLE AND BASIC of all additive techniques and yet it never grows old. Using a pre-painted sheet of wallpaper, experiment with different types of splatter, then go in with a paper towel to tone back or lighten some of the splatter marks if you desire.

MATERIALS LIST

- acrylic paint
- paintbrush
- paper towels
- spray bottle with water
- toothbrush
- wallpaper pieces

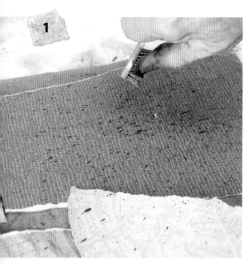

1. Load an old toothbrush full with watered-down acrylic paint and flick your thumbnail across it to release a fine splatter texture onto a painted and/or patterned wallpaper sample.

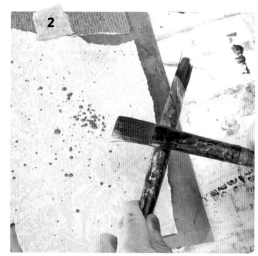

2. Load a paintbrush full with watered-down acrylic paint and tap it against a second paintbrush, holding both over your wallpaper, to release a medium splatter texture.

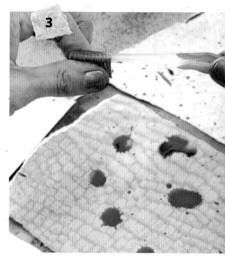

3. Load your paintbrush full of watered-down acrylic and squeeze the bristles between your thumb and forefinger to release large droplets of color.

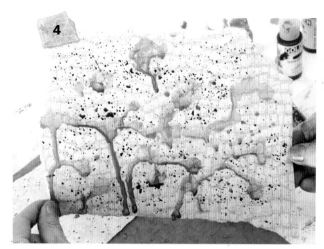

4. Experiment with the amount of water added to the paint and the angle of the splatter. If you lift the paper while the splatter is still wet, you can encourage the larger splats to drip down the sheet.

5. Wrap a paper towel over your pointer finger. Using your finger tip, lightly lift any large splats that bleed together and have become too prominent or any drips you wish to remove or lighten.

ADDITIVE PAINTING TECHNIQUE
Handmade Hot Glue Stamp

ONE STICK OF GLUE AND A GLUE GUN will give you enough material to create your own stencil about 4" (10cm) across. You can add additional glue sticks and expand on this to create a larger stencil, but you can successfully move the small stencil across the paper to cover a large area. The beauty of creating your own stencil design pattern is that you will never see it being used in any other artists' work; it will be completely and totally your own.

MATERIALS LIST

acrylic paint

hot glue gun and glue sticks

paper, patterned, rice or other

parchment paper or craft mat

sponge

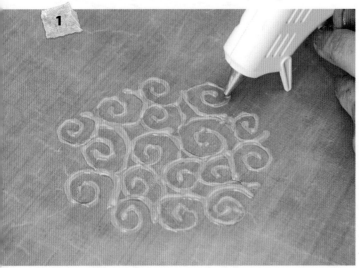

1. Using a glue gun, make a stencil pattern on parchment paper or a craft mat. Keep in mind that you will need to close the shapes so the stencil holds together after it has dried.

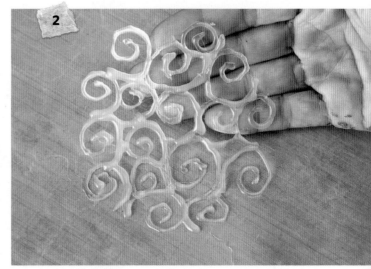

2. When the glue is completely dry, peel the stencil up and remove it from the parchment paper.

3. With a sponge paint through the stencil to leave a negative pattern on the paper.

4. Keep adding paint and checking on your design to make sure you get your desired look.

ADDITIVE PAINTING TECHNIQUE
Sea Sponge

REMEMBER THE SPONGE PAINTING CRAZE? Faux finishes are not just for your dining room walls; sponge painting also makes great collage papers.

MATERIALS LIST

acrylic paint

paintbrush

rice paper

sea sponge

stencil

1. Tint rice paper with an acrylic wash. Choose a rounded sea sponge that fits nicely into the palm of your hand and offers a nice round shape. Dip the sponge in undiluted fluid acrylic paint.

2. Wash over the paper with a translucent layer of watered-down fluid acrylic to tone back the high contrast. Lay down a store-bought stencil and lightly sponge through the stencil with a darker acrylic color.

3. Lift the stencil to see if you need to add any more acrylic paint through your stencil with your sponge.

Finished Sample

SUBTRACTIVE PAINTING TECHNIQUE
Inkblot Test

THIS PERSONALITY TEST WAS PUBLISHED IN 1921 by Hermann Rorschach, who was a psychiatrist from Switzerland. For our purposes the duplication of a pattern from one side of the paper to the other, achieved by pressing the sides together, forms interesting patterns, psychological or not!

MATERIALS LIST

acrylic paint

cup with water

hand-carved stamp

paper, old book page

paper towels

spray bottle with water

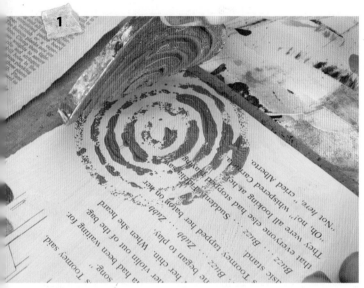

1. Paint a page from an old book with a solid wash of color. Allow to dry completely. Use hand-carved stamps to add effects to one half of the page.

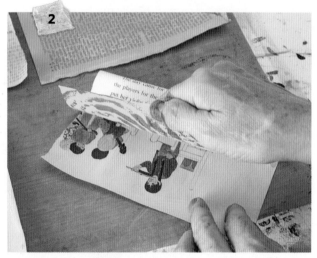

2. Fold the page in half to transfer the effects from the stamped side to the clean side.

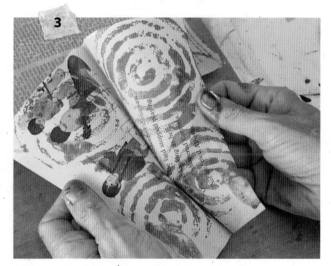

3. Repeat with various techniques from the previous demonstrations on one half of the sheet and fold to transfer.

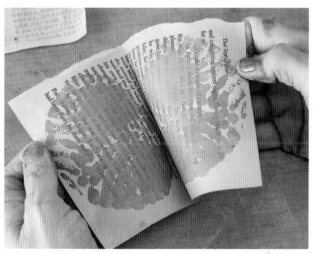

Variations

A second carved stamp is used here with more watered-down paint to give a more organic effect with soft edges. Experiment also with brushing, dabbing, splattering and sponging the paint onto the paper before folding and pressing to the other side.

Blotter Paper

OFTENTIMES THE BLOTTER PAPER IS THE BEST PAPER you make all day because you are not fretting or stressing over what it will look like; it's just a sheet of paper to pick up extra paint with.

When the blotter paper is pretty well covered with color, you may choose to wash over the sheet to tone down the contrast of the white areas. This may be done with one or many colors.

MATERIALS LIST

paint

paintbrush

rice paper

sheet of paper

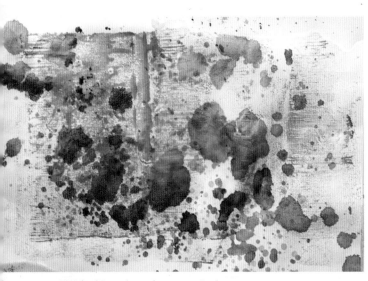

Finished Sample
Paint a sheet of rice paper with rapid, wide strokes and random splatters.

Working quickly while the paint is still wet, press a clean sheet of paper into the painted paper to remove excess paint and make an impression of the original page.

This can be done throughout your painting session to pick up extra paint from your work surface, from a saturated sheet, from an effect gone bad and so on. Keep adding to the blotter paper until the end of your painting session, and then make something wonderful from it.

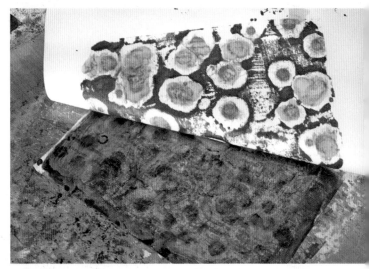

Blotting Excess Paint
Make your paint and paper go further by blotting excess paint (and alcohol in this sample—see the alcohol resist technique for more) by pressing a piece of paper onto your resisted paper.

MAKE ADDITIONAL PRINTS

You might have an excess of paint on your paper, and you might feel like you want to blot that excess off. Consider doing so using a piece of rice paper as your blotting paper—you'll get additional prints to use in your collage work.

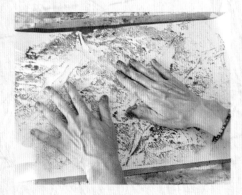

RESIST TECHNIQUE
Alcohol Resist

MATERIALS LIST

acrylic paint

eyedropper and/or spray bottle

isopropyl rubbing alcohol

paintbrush

nonabsorbent found paper, such as book pages, maps or invoices from art supply orders

RUBBING ALCOHOL (UNDILUTED ISOPROPYL RUBBING ALCOHOL) from the first-aid aisle of your local drug or grocery store pushes acrylic paint pigments away and can demonstrate some wonderful resist techniques.

So many variables come into play with this technique: the type of paper and its absorbency, the amount of water in the top layer of paint, and how dry the paint is when you drop the alcohol. It's best to experiment with this technique many times to get the best results.

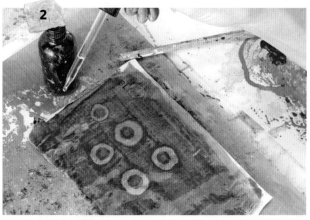

1. Paint the paper with a light color of paint and allow the paint to dry completely. Consider using some of the additive techniques we've explored.

Overlay a darker, watered-down fluid acrylic paint on the prepared paper and allow to dry just slightly.

2. Drop alcohol from an eyedropper from varying heights and with varying force to form large and small droplets on the paper.

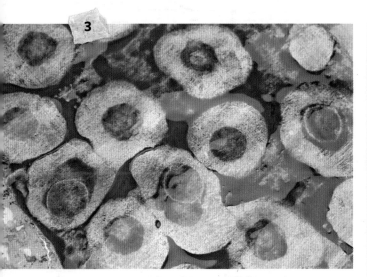

3. Watch the alcohol resist push your top (wet) layer of paint away, revealing the lighter layer underneath. If your top layer of paint is too wet, it will roll back into the resist space; if the paint used in your top layer is too dry, it will not move or resist with the addition of alcohol. This technique requires patience and experimentation. If at first you don't succeed, try, try again.

ALCOHOL RESISTS ON PRE-PAINTED PAPERS

To really amp up and customize your papers, try using this alcohol resist technique on a piece of paper you have already painted. Here I am dropping alcohol onto a paper I created with the texture-rubbing technique.

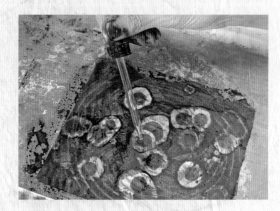

RESIST TECHNIQUE
Texture Rubbing

MATERIALS LIST

acrylic paint crayons

paintbrush

rice paper of found paper

texture plate or other textured surface

I LOVE TO DO CRAYON TEXTURE RUBBINGS OUTDOORS on surfaces I come across serendipitously. I store these rubbings for future painting and patterning in a studio drawer. Some of my crayon rubbings include old gravestones, sidewalk bricks, bottoms of shoes, wood, metal, stone and patio furniture or tabletops at outdoor eateries. Light crayon works well when overlaid with dark paint, and dark crayon works well when overlaid with medium or light paint. Playing with color combinations of crayon and paint can produce diverse results.

My Preferred Crayons

Melissa and Doug Triangular Crayons are ingenious in their shape. Made of plastic, not wax (for additional durability), this multiset of rainbow color crayons stay on the table—just where your put them. Their unique shape helps with gripping, the flat sides work great when rubbing across texture plates or stencils, and the pointed tips are great for mark making. They also come without papers, saving you time picking and peeling.

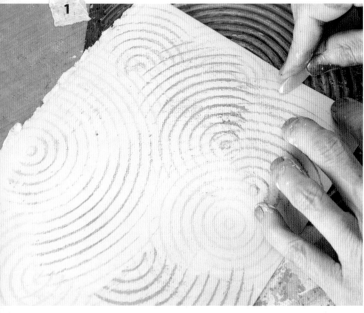

1. Lay a piece of rice paper or found paper over a texture plate. Using the side of a paper-free crayon, rub a solid layer of wax onto the paper.

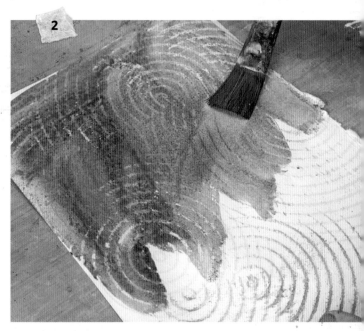

2. Wash over the crayon marks with a darker color paint and watch crayon wax resist the fluid acrylic.

EXPERIMENT WITH OTHER TEXTURE SOURCES

Back to one of my favorites—shoe soles. Repeat steps 1 and 2 using a shoe sole or other unique or overlooked item as your texture source. In this example I painted dark paint over light crayon. I also painted the back of the paper rather than over the crayon.

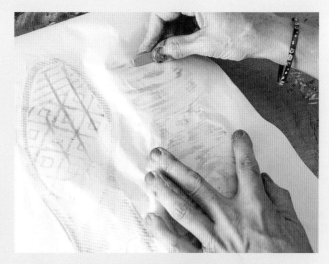

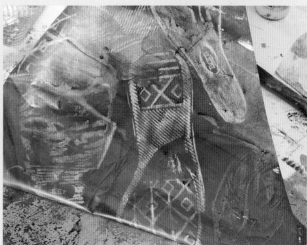

RESIST TECHNIQUE
Soap Bubble Resist

MATERIALS LIST

- acrylic paint
- liquid soap
- paintbrush
- paper, perhaps an old book page
- spray bottle with water

MANY VARIABLES COME INTO PLAY with this resist technique, so experimentation is paramount. The amount of water in the diluted top coat plays a role. The amount of drying time before spraying the soap bubbles plays a role. The color of the paint pigment can even play a role. Experimentation is key.

1. Use a piece of paper that will not allow the paint to soak all the way through, such as an old book page. Coat the paper with a light-colored acrylic paint. Allow the paint to dry completely. Brush over the top of your painted sheet with a darker color of diluted fluid acrylic paint (much like in the alcohol resist technique).

2. While the top layer is still wet, gently spray the soap bubble mixture and allow the droplets to fall onto the paper. Try to spray the soap mixture up in air and let it fall straight down onto the paper in small droplets. Watch the soap bubbles repel the top layer of paint in a small pattern of spots that sometimes grows bigger and bigger.

3. If you want to get fancy, allow this layer of paint to dry and then add another layer of paint. Or in step 1, use multiple colors of paint for your base painting.

NO MAGIC RECIPE NEEDED!

A few pumps of dish soap and a little water is all that is needed to create the bubbles. Just do not use the kind of soap with lotion in it.

Metallic and Iridescent Decorative Papers

AS MUCH AS I AVOID DYE-BASED DECORATIVE PAPERS because of their tendency to fade, I love white, light and natural decorative papers from the art store for hand-painting. (If a dark paper is the only one available or the one that really catches your eye, you can use that too; it can only successfully be painted a darker color though, not lighter, as fluid acrylics are translucent.)

Purchased papers with metallic, opalescent or iridescent patterning work wonderfully with resist effects when painted with fluid acrylics. Fluid acrylic paints are resisted by these types of finishes; the paint adheres only to the paper itself.

It's important to purchase decorative papers in white or natural when you can. Because fluid acrylics are translucent, the color of the paper will always show through the paint. When you start with white or natural paper, you can tint the paint as light a color as yellow and as dark a color as deep purple.

MATERIALS LIST

acrylic paint

paintbrush

rice paper or previously created paper

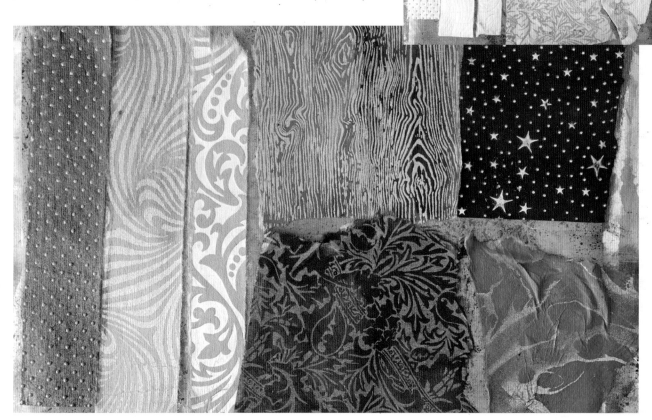

Before and After
My store-bought papers before I painted them are above right. Directly above are the same papers after they were painted and allowed to dry. They are now so much more versatile and interesting. They have all maintained their metallic and iridescent features but have so much more character now that they have color.

ALTERING STORE-BOUGHT
METALLIC AND IRIDESCENT PAPERS

To make custom papers from your store-bought papers, just water down fluid acrylic paint and wash over the surface of the paper. (Fluid acrylics resist really well off the metallic elements. Full body (tube) paints do not work well and may cause frustration.) Feel free to experiment here as well, as you may get different results from painting on the back versus the front of the paper.

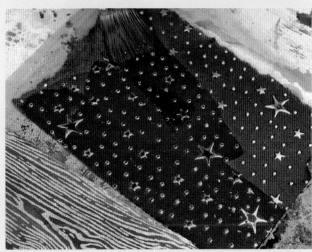

RESIST TECHNIQUE
Glue Resist

MATERIALS LIST

acrylic paint

Elmer's glue

hairdryer (optional)

paintbrush

paper, book page or newsprint

paper towel

BASIC ELMER'S GLUE CAN BE SQUEEZED AND DRIPPED directly from the bottle onto an unpainted surface to form a pattern that will resist acrylic paint. This glue technique works well on printed and found papers as well as unprinted rice papers with multiple layers of paint. Experiment with different drizzle patterns as well as levels of wiping to remove paint from the resist pattern.

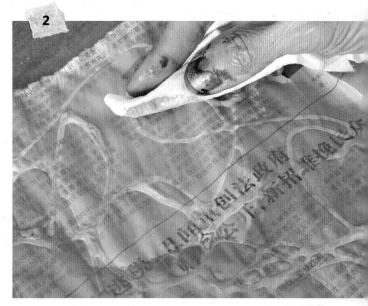

1. Using Elmer's glue, squeeze out a design onto your paper. Try swirls, dots or something else with a soft organic feel. Allow the glue to dry completely—you can speed drying time with a hair dryer if desired. Then paint over the glue design with fluid acrylic paint and watch the glue resist the paint.

2. Use a paper towel to wipe even more paint from the glue.

ALTERNATIVES TO GLUE

Feel free to experiment with other types of glue and acrylic texture products. I especially like the effect I get when I use Golden clear tar gel. Golden clear tar gel is a 100% acrylic polymer dispersion colorless gel with an extremely resinous, syrupy, stringy and tar-like consistency. It is a unique product with a long rheology; conceivably it could be poured from a three-story building as one long strand! Clear tar gel can be used to generate fine detailed lines by dripping it over painting surfaces.

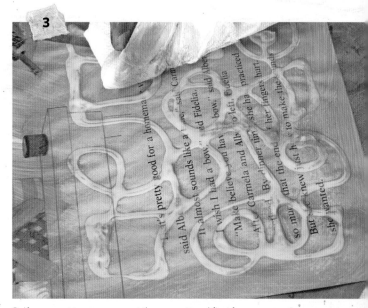

3. If you want to, you can wet the paper towel first for an even crisper removal of the paint from the glue.

RESIST TECHNIQUE
Gel Medium Resist

I STAMPED A PATTERN utilizing my own hand-carved stamp onto old sheet music with gel medium and let it dry. The gel medium will act as a resist when color is applied. You can remove more or less paint to create the desired effect by rubbing with a paper towel.

MATERIALS LIST

acrylic paint

gloss gel medium

hand-carved stamps

paintbrush

paper, white or patterned

paper towel

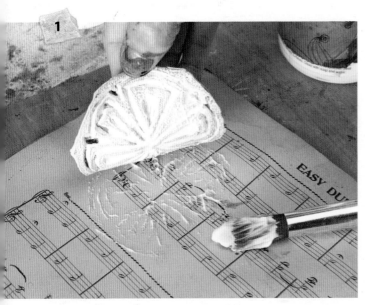

1. Paint gloss gel medium onto a hand-carved stamp. Stamp over the paper. Allow the gel medium to dry completely. Use more than one stamp to add visual interest.

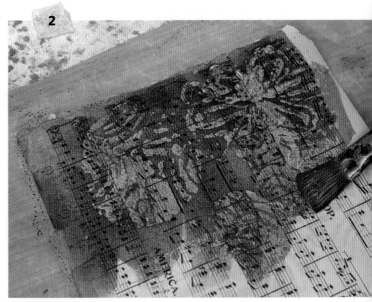

3. Take a paper towel and wipe the page down to remove paint from the gel medium area.

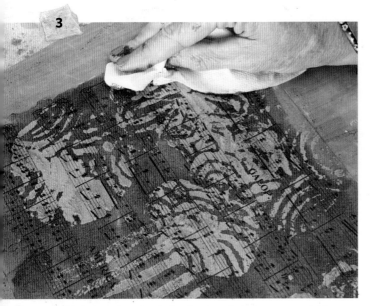

2. Wash translucent paints over the gel medium stamp marks and watch how the paint takes to the gel medium differently than it does to the unprimed paper.

Gesso Resist

I STAMPED A PATTERN utilizing my own hand-carved stamps onto rice paper with white gesso and let it dry. The gesso will accept the acrylic color in a different manner than the paper and act as a resist when paint is applied.

MATERIALS LIST

acrylic paint

brayer

hand-carved stamps

paintbrush

white gesso

white patterned/store bought paper, optional

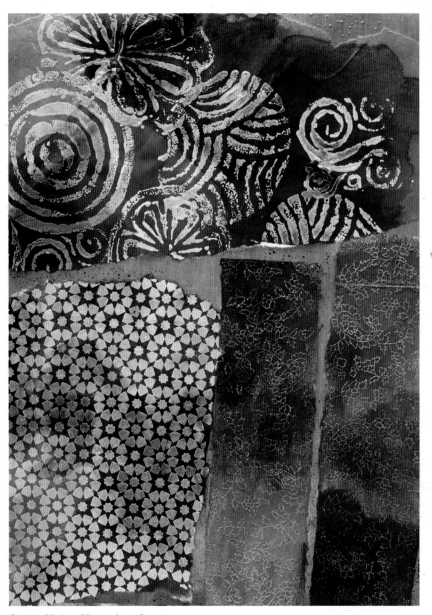

BEWARE!

Using stamps you have carved yourself eliminates the possibility that anyone else will have the same patterning in their hand-painted papers. Also, if you intend to use your papers for artwork that will be reproduced for the mass market, you need to know that some commercial stamps are copyright protected.

Gessoed Painted Paper Sampling

The paper on the top was created using a rubber stamp and gesso. You can achieve a similar effect by painting store-bought papers that have a white design printed on or embedded in the paper (see sidebar). The white pattern will resist the paint similar to how metallic and iridescent patterns will resist paint.

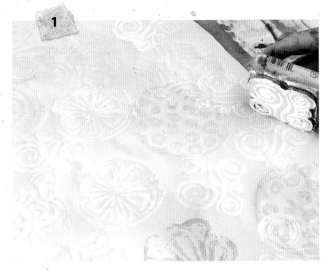

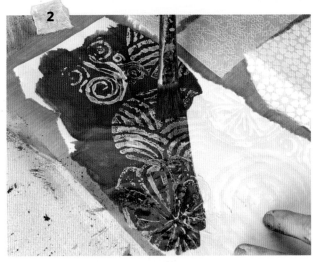

1. Brayer white gesso onto a hand-carved stamps. Stamp over white or patterned paper. Allow the gesso to dry completely.

2. Wash translucent paints over the gesso stamp marks and watch how the paint takes to the gesso differently than it does to unprimed paper.

ALTERING STORE-BOUGHT WHITE PAPERS

To make custom papers from your store-bought papers, use fluid acrylic paint and wash over the surface of the paper. Feel free to experiment here as well, as you may get different results from painting on the back versus the front of the paper.

Consider blotting a piece of rice paper over the top of this paper while it is still wet in order to transfer the pattern.

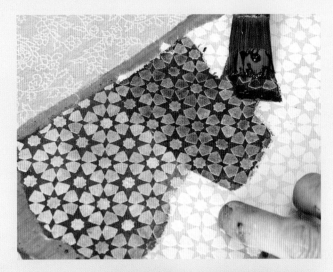

Gelli Plate Monoprinting

MATERIALS LIST

brayer

fluid acrylic paint

Gelli Arts printing plate

miscellaneous stencils, tools and materials

rice paper or other paper as desired

GELLI PRINTING HAS BECOME A WIDESPREAD PHENOMENON among artists. You can even find recipes floating around the Internet for how to make your own gelatin plate. You can entertain this idea if you'd like, but I find purchasing a plate to be much less time intensive, and it also leaves you with a lot more room in your refrigerator.

Monoprinting is most effective when prints are layered over and over themselves. Multilayering presents a wonderful effect, adding depth and texture to your hand-painted papers. There are several tutorial videos on YouTube and the Gelli Arts website that will have you addicted to the technique in no time.

In a nutshell, a thin, undiluted layer of fluid acrylic paint is added to the plate with a brayer. Use tools, stamps, stencils and household objects to remove and mask the layer of paint from the Gelli plate. Scratch in lines and remove paint from the plate with various tools, or mask paint by applying a stencil. A hand-carved stamp is good for removing paint. Once satisfied with the plate, press a piece of paper to make a print. Quickly remove the paper and any masks, then pull a second print, or a ghost print, if there is enough paint remaining on the plate.

Visit gelliarts.com for plenty of tutorials.

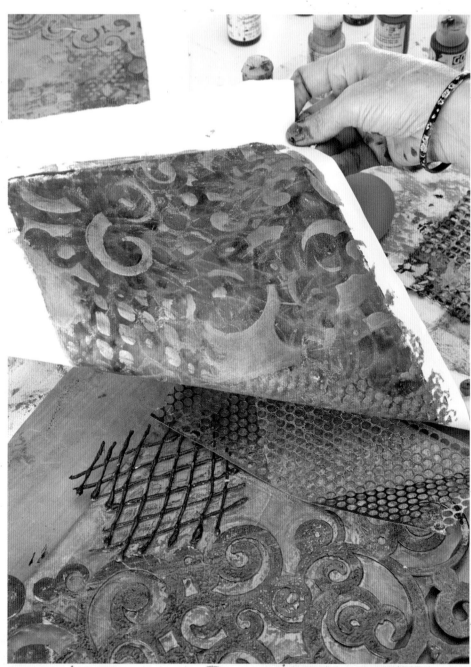

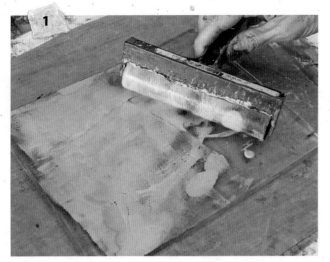

1. Brayer a thin layer of undiluted fluid acrylic to the plate.

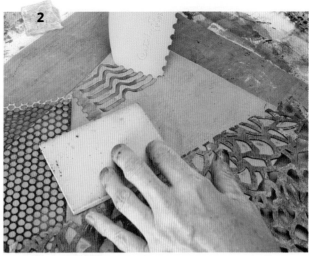

2. Layer a stencil over one corner of the plate to mask the paint.

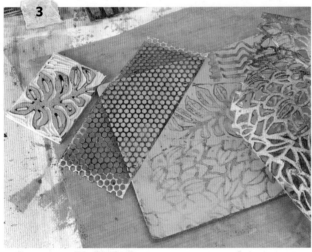

3. Press stamps and household items into the paint to remove paint from the plate.

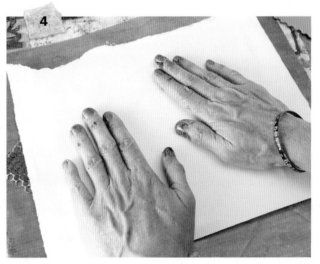

4. Press paper onto the plate to pull the first print, which will remove all paint that is not being masked by a stencil.

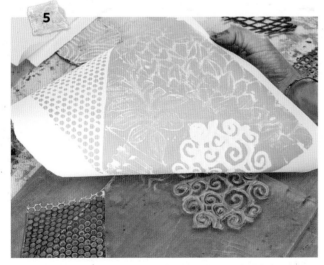

5. Remove masking stencils and pull a second print. Re-ink the plate and experiment with the same techniques in different colors over the previously printed paper.

6. Lay down a piece of paper and press to pick up paint remaining from previous pulls. These are the simplest and most basic of first layer prints.

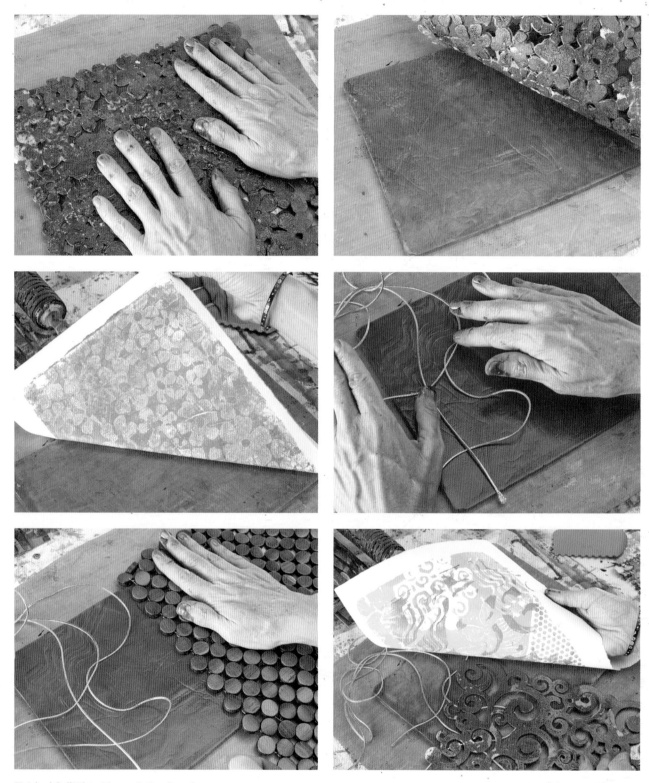

Finished Gelli Plate Monoprinting Samples

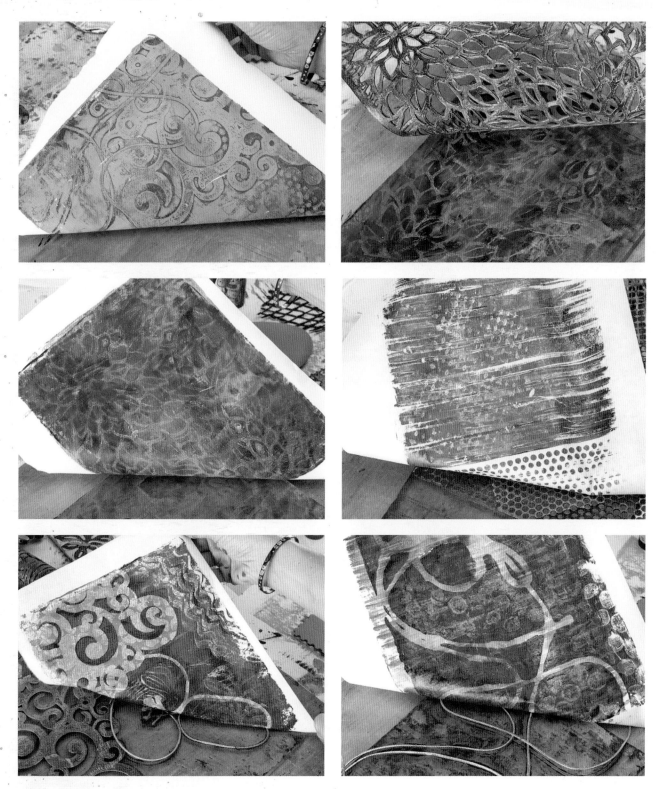

Finished Gelli Plate Monoprinting Samples

Creating Collage: The Process

COMPOSITION IS AN IMPORTANT CONSIDERATION in any medium. Collage is no different. In this chapter we will explore what makes a good composition and we'll talk about working from photos and the importance of a good pencil sketch. From that sketch, I always create an acrylic underpainting that reinforces good composition and design, develops color balance and pays close attention to shading and volume of the subject. A full range of values in the underpainting can make all the difference in the success of the final collage.

As we add papers on top of the painting, we use the well established shading and values that we worked out in the painting as our guide map. Auditioning papers is the process of holding your hand-painted papers up to your underpainting and making sure they are light enough or dark enough. We also need to consider the shapes of the tidbits of paper and, in fact, how the paper is torn, which is important in achieving realistic volume.

We will also discuss the basics of substrates and gluing, and we'll go next level with techniques for working with mixed media, creating restful and negative space, using arbitrary color and more.

Pay close attention. These are the nuts and bolts of creating a painterly collage!

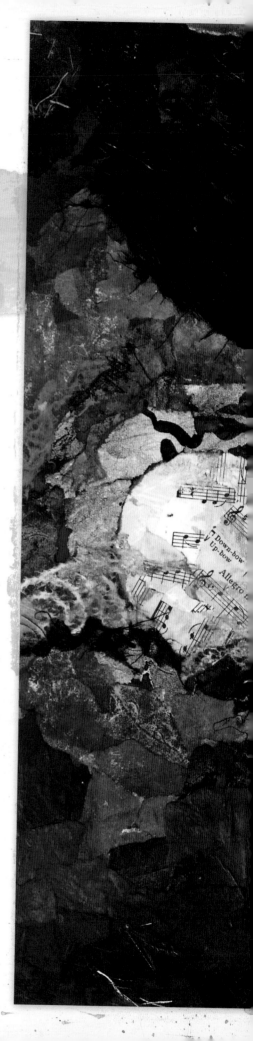

OVER THE MOON
Collage of hand-painted paper on wood panel

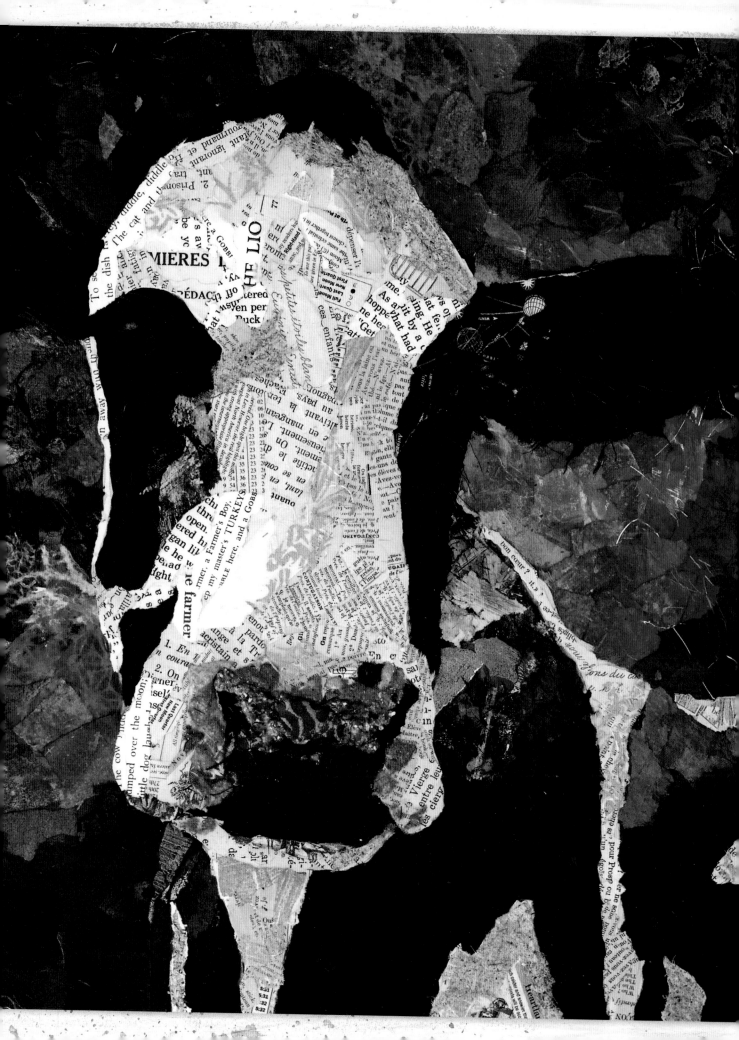

Substrates and Priming

WOOD, CANVAS OR BOARD AND BUILDING VERSUS BUYING

When framing my work in traditional molding, I work on ¼"(6mm) sanded hardwood panels available from Home Depot. I buy precut pieces [24" × 24" (61cm × 61cm) or 24" × 48" (61cm × 123cm)]. These precut pieces can be cut down to smaller sizes at the store [I recommend against cutting them smaller than 12" × 12" (61cm × 61cm)]. You can cut them down to size yourself using a little elbow grease and a utility knife with a new blade. These panels are thin; they are not standard plywood thickness.

As an alternative to having to cut wood, a product I really like is American Easel wood painting panels. These presanded panels are available at dickblick.com. They are "gallery wrapped" wood panels that can be hung without frame molding. They also sit very nicely in a floater frame. Pre-gessoed boards are another option (Ampersand makes a good one).

The reason I work on wood versus canvas is simple: You can push the glue into and against wood without experiencing "give." Stretched canvas does not offer enough resistance for some of the thicker, more highly textured papers that require more pressure and more glue. In addition, wood resists warping, especially the boxed panels. Since I do not frame under glass, warping can be an issue with any mat board or foamcore type of substrate.

I seal my wood panels with Golden GAC 100 or Liquitex clear gesso. The gesso has more tooth, which is good for sketching but bad for erasing. The GAC 100 is pretty slick, which is bad for sketching, but good for erasing. My solution: Sketch on the raw wood, then prime with either GAC 100 or clear gesso over the pencil sketch. If you do not desire the wood grain to show in your art, you can prime the wood with basic white gesso, black gesso or colored gesso (Holbein makes some juicy colored gessos).

Substrate Options
I prefer to work on wood surfaces. Handcut ¼" (6mm) panels and pre-gessoed cradled panels from Ampersand are a couple that I use regularly.

Glues and Varnishes

BRANDS AND PRODUCTS

Liquitex gloss gel medium is a high-viscosity medium that dries to a crystal-clear gloss finish and makes an excellent collage glue. Translucent when wet, it is transparent to translucent when dry, depending on the thickness of the application. I prefer to use gloss medium as my glue as opposed to matte medium because it does not dull the intensity of my colors with matting agents. If you prefer a matte finish, choose a matte or satin varnish for your final two coats of sealer.

I work standing at an easel, and this is another reason why gel medium is a good choice: Gel doesn't run down the panel and puddle on your easel shelf. It stays where you put it. Also gel is the consistency you need when putting it down on thicker, more resistant papers.

Golden polymer varnish with UVLS (ultraviolet light stabilizers) is a waterborne acrylic polymer varnish that dries to a protective, flexible, dust-resistant surface. I use this product as my final sealant over collage. It is important to note polymer varnishes must be thinned before use. They have been formulated to be thicker than traditional varnishes to maintain an even suspension of matting agents. This ensures more consistency in surface reflectance.

Varnishes are available in a highly reflective gloss and an exceptionally flat matte. The matte varnish will lighten dark value colors.

I prefer something more in the middle, a satin finish. If you want to mix your own version of satin, experiment with a combination of matte and gloss varnishes that meet your personal preference. I combine approximately 80% matte with 20% gloss and dilute that with 20% water.

Glue and Varnish Options
Liquitex gloss gel medium and Golden polymer varnish with UVLS are two of the products I use regularly. Since I use a lot of each I buy the biggest containers I can.

Working with Reference Photos

REFERENCE INFORMATION AND RESOURCES COPYRIGHT

There are several places online where you can find copyright-free images to use freely and completely for your reference. morguefile.com is my favorite. Through this site, photographers post photos free of any restrictions of use. You may paint these images to your heart's content. But beware: This is not something you can do with any photo you find online. Most photographers copyright their images, and without permission you are not legally allowed to use them for your own reference. How do you get around this? I suggest contacting the photographer and telling them what you're up to—tell him or her you are an artist and you'd love to use their image as a painting reference. If you ask nicely—and before you get started painting—many photographers are flattered and will give you permission to paint using their pictures as reference.

Other resources you may want to check out include:
paintmyphotonow.com
dreamstime.com/free-photos

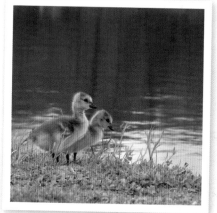

Photo courtesy of morguefile.com.

Photo courtesy of Alex G. Olivera/AGO Action Photography.

Reference Photos

I like to paint birds because they offer so much texture and color in their feathers and patterns provided by Mother Nature. Many people have personal associations with birds that make them a subject matter that sells well. I would say the most popular small birds for me are cardinals and lovebirds. On the larger side, peacocks and roosters are always popular. Pier 1 Imports sells a print of a nesting robin collage that I created a number of years ago; it's one of their best-selling pieces of wall art!

If you do a Google search and find a photo online you *must* ask permission from the photographer to use the photo as a reference. I recently approached a photographer from Facebook about using his small songbird photos as a painting reference; he was flattered and gave me carte blanche permission to use his images. You will often find that people are happy to help when you ask permission first.

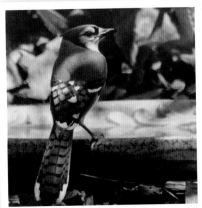

Photo courtesy of Cherie Bosela.

Composition

COMPELLING DESIGN

Perhaps it's my years spent as a professional graphic artist or simply the fact that collage is a busy medium, but it should be apparent by now that my work typically features a large subject in the foreground with a relatively simple background. Like any good ad layout, the product is prominent and king. Everything else is secondary and only there to support the king.

Let's examine for a moment the statement that collage is a busy medium. There are lots of competing elements, from the viewer trying to "read" the related materials to the multiple textures to the variety of colors and sizes of torn paper pieces. Because of all this competition for the viewer's eye, the most successful compositions are simple. Consider one large point of focus with a simple background. Choose a large vase of flowers, the head of a cow, one bird on a branch … you get the idea. Make your point of focus the thing with the most detail and let the rest be simple.

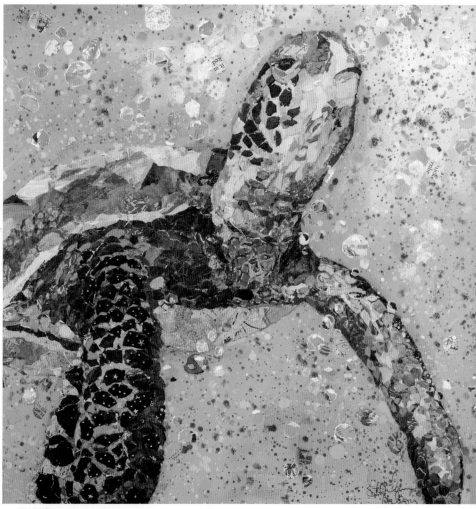

Make the Subject the Star

As a graphic artist for more than twenty years I know good composition intuitively. Collage in my style always features one large subject and a relatively simple background in order to make the subject the star. Notice, for example, the simple background in *Water Baby*. I have anchored the subject in the composition by running him off at least one side—preferably two sides—of the picture plane. This way the subject is not simply floating in the center of the composition. I also integrated the collaged bubbles in the background by making sure they intersect with the subject versus just floating around him. This connects the turtle to the bubbles, which disperse into the painted water background. All elements of mixed media need to be tied together this way.

▲ **WATER BABY**
(Cover art for the 2013 Florida Keys Arts Council *Culture Magazine*.)
Collage of hand-painted papers with acrylic on wood panel

Manual Composition Manipulation

ARRANGING YOUR COMPOSITION WITH PAPER AND SCISSORS

Typically I cut pieces and parts for the composition I desire from multiple photo reference sources. For example, I might cut out a cow from one photo, a barn on the horizon from another, a stalk of corn from a vertical photo and a cloudy horizontal sky from another. I cut all these elements out with scissors and move them around until I land on a composition I love.

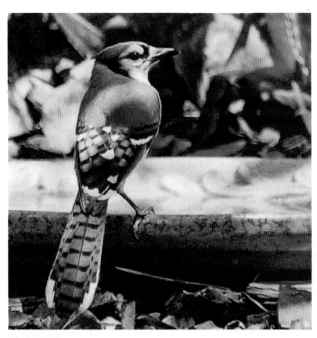

My Subject
The blue jay will be my subject. He has some nice detail (especially in his feathers) that will be fun to collage. I also like the way he perches on the edge of the birdbath. But the background is entirely too busy, and if I replicated that in collage it would result in a too-busy collage, and I'm afraid the blue jay would get lost in it all. So I cut around the bird, his bath and the foreground area of the photo. I'll keep that part and I'll throw away the background. (Photo courtesy of Cherie Bosela.)

SAMPLE COLLAGE DEMONSTRATION SUBJECT

Throughout this section of the book I will demonstrate the various steps necessary to create a painted paper collage using a blue jay (yes, a bird again!) as my main subject. I will also use other finished paper paintings to demonstrate some of the process steps.

My Background

I've decided to go with this photo (or parts of it) for my background. It is much simpler than the original background, and I think it will give a sense of depth to my collage.

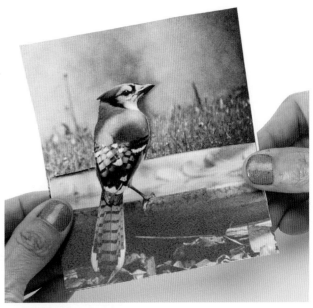

Audition the Composition

I move the pieces around until I rest upon the composition and proportions that work for me.

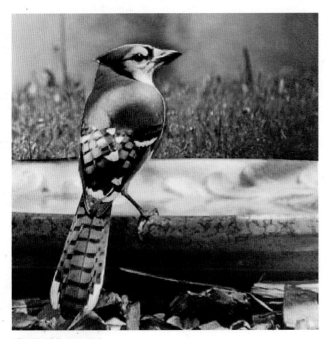

The Final Composition

This is my final working composition. The composition features many well-defined areas and a clear subject, background and foreground. Admittedly, this is a particularly simple composition in terms of the number of pieces I placed, but it's a good example to start your collage experience with.

COMPUTER-GENERATED COMPOSITION

I often use Photoshop® to build my compositions as well. I clip out each element of the composition and save it to its own Photoshop layer. Then I simply slide the layers back and forth until I am happy with the result. One benefit of using the computer to develop your compositions is that you can resize any of your layers as it suits you. This can make all the difference in your composition. I urge you to give it a try if you have the Photoshop skills to do so.

Sketching Basics

I PREFER TO USE PENCILS that are a mixture of graphite and varnish. This formula helps keep the sketch from smearing when you apply clear primer or paint over it.

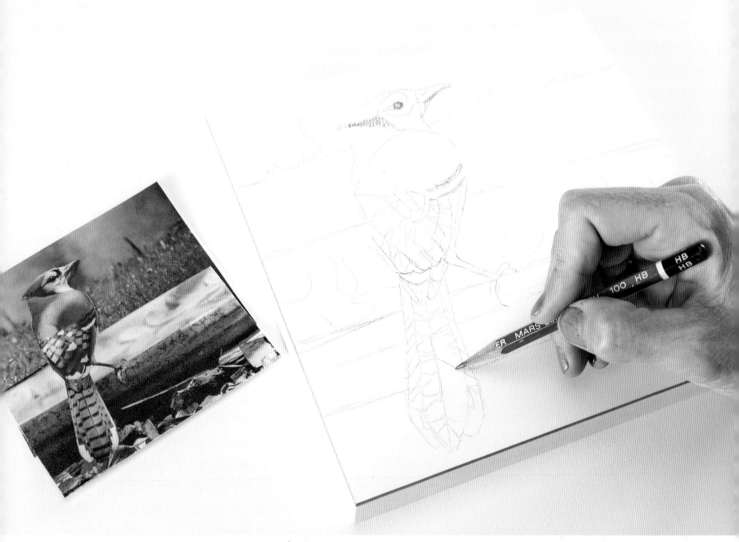

Basic Sketching
Working from my manipulated photo reference, I sketch out the composition onto a clear-, white- or colored-gesso primed wood panel.

Underpainting Basics

AFTER THE SKETCH COMES THE UNDERPAINTING, and the underpainting should not be highly detailed. I use the underpainting process for two reasons:

- I like to block in all my colors so that when I apply the paper over the top, if any spaces are left between bits of paper, the color of the underpainting shows rather than the color of the wood.
- It is during the underpainting process that I work out my values—light, dark and medium tones.

I also work out my colors during this part of the process. It's much easier and quicker to work out these challenges with paint than to have to work and rework the collage. Once I get the values and colors to my liking, I let the painting dry completely.

I use fluid and full-bodied acrylics for the underpainting. When I do drippy, splattered backgrounds, I use strictly fluid acrylics thinned with water or acrylic medium or both. I like leaving the wood grain showing through these drippy areas. When letting the wood show through, I'll either leave it natural or stain it with a diluted yellow/gold/ochre fluid acrylic.

Don't spend tons of time laboring over your underpainting; use the underpainting process as an exercise to help you determine where your values are and what colors you will use in your collage. Sometimes I'll paint the underpainting the complementary color (the color across the color wheel from my main color) of the collage paper I intend to use on top, letting some of that color peek through for a vibrant, interesting effect.

And just to emphasize one more time: Do not fall in love with your underpainting! Do not take this to a level of finished detail that you love so much that you will not want to apply collage over the top.

1. Lay in a simple background wash. Keep the color of the background lighter than that of the main subject.

2. Add details of the subject, focusing on simple shapes that can be later achieved with collage papers.

3. For finishing touches add a simple background in darker colors than the bird toward the bottom and lighter at the top. Make sure the bird stands out in contrast.

A Full Range of Values and the Importance of Shading

SHADING, SHADING, SHADING: In the underpainting, establishing a likeness, laying down color and shading are the most important goals to achieve. The latter is the most important information for this collage-application road map. The shading of the painting will help to guide the paper gluing, so you are creating volume with your paper brushstrokes.

Where is the darkest dark? Where is the lightest highlight? Where is the medium value? How does it gradually transition to light and to dark? How light is the light side? What is the direction of the light source? These are all questions that are sorted out and answered in the underpainting stage so that the collage application can simply follow these established shading guidelines.

Once you have established an underpainting with a full range of values (from the darkest dark to the lightest light and every value in between), you will be ready for collage application.

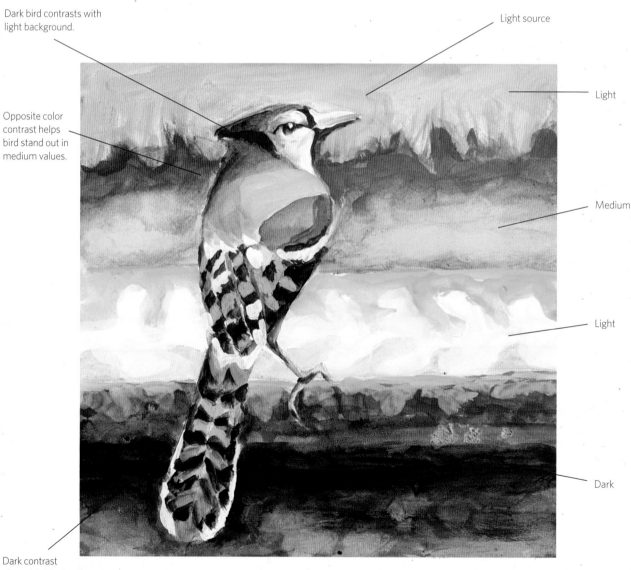

Dark bird contrasts with light background.

Light source

Light

Opposite color contrast helps bird stand out in medium values.

Medium

Light

Dark

Dark contrast allows bird to stand out at the bottom.

Underpainting establishes color, shading and composition. A full range of values is important but details can be loose. We get more detailed in the collage application, but we use the values established in the underpainting as an accurate guide for shading (which creates volume) in choosing papers to glue on top.

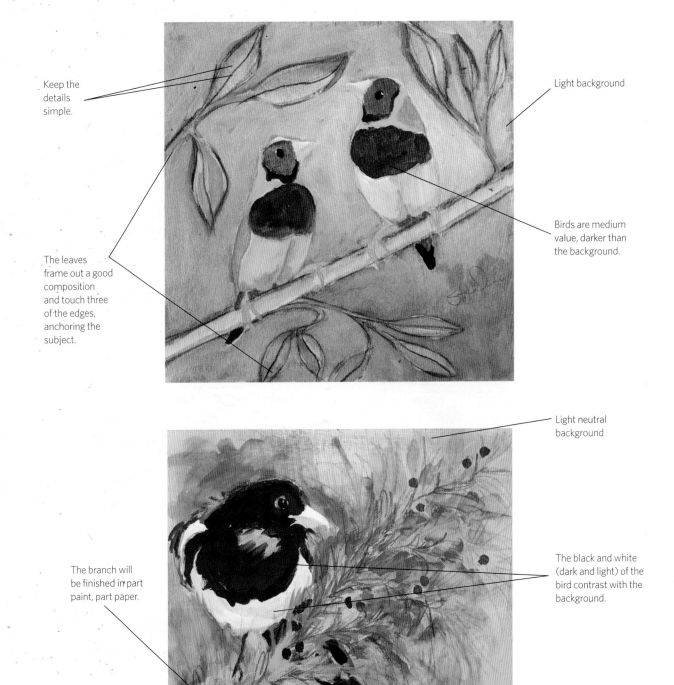

Keep the details simple.

Light background

The leaves frame out a good composition and touch three of the edges, anchoring the subject.

Birds are medium value, darker than the background.

Light neutral background

The branch will be finished in part paint, part paper.

The black and white (dark and light) of the bird contrast with the background.

Simple shapes in the tail feathers

Simple Shapes

BREAKING DOWN THE FORM

Look at your subject. Closer. Closer. Ask yourself, "How can I represent this in the simplest of shapes?" The fold-over of a dog's ear is formed with a simple angled line and a half moon at the bottom. The handle of a coffee cup is about the little crescent shape in the handle that shows it flipping over and around to form the finger area. The fur on the forehead of a cow is created using long thin tears moving in multiple opposing directions. Break it down into basic and simple shapes, and the impression of your subject will follow.

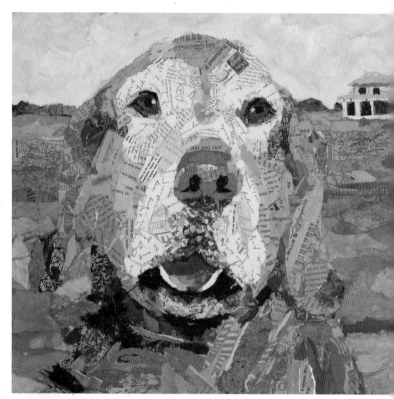

▲ HERE, BOY
Collage of hand-painted papers with acrylic and pencil on die-cut wood panel

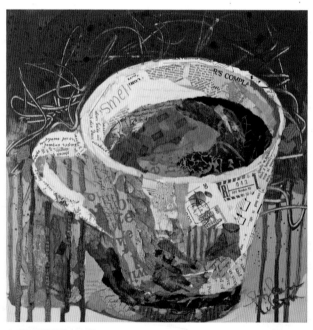

▲ COFFEE TALK #2
(This art was featured on the set of an episode of *NCIS: New Orleans.*)
Collage of hand-painted paper with acrylic on wood panel

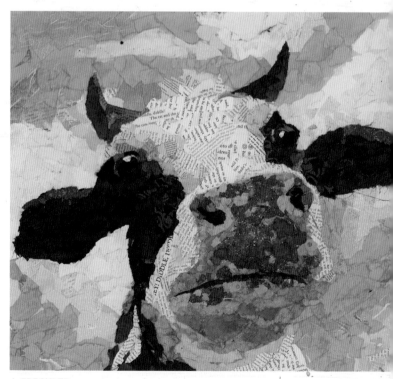

▲ FRECKLES
Collage of hand-painted papers on wood panel

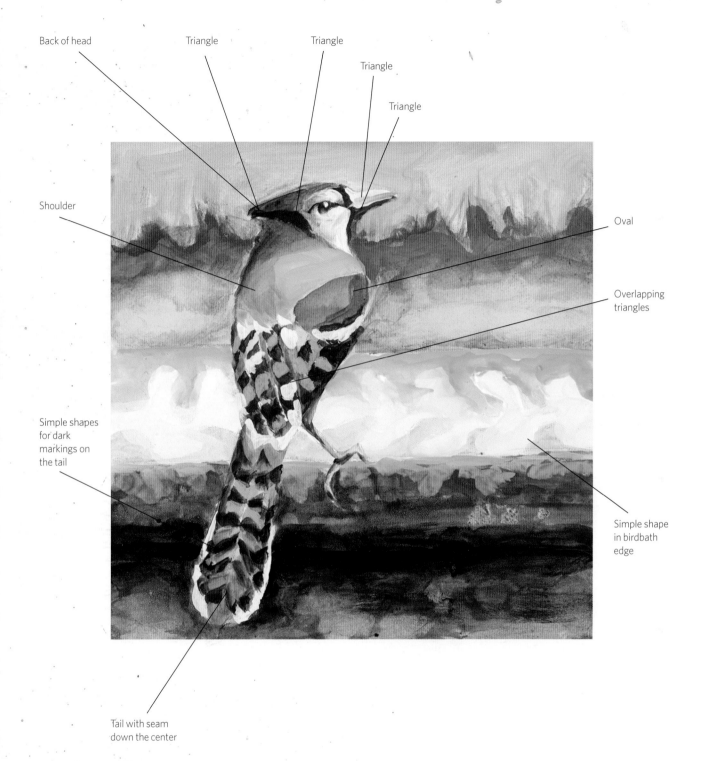

Back of head

Triangle

Triangle

Triangle

Triangle

Shoulder

Oval

Overlapping triangles

Simple shapes for dark markings on the tail

Simple shape in birdbath edge

Tail with seam down the center

COLLAGE PROCESS
Gluing

KEEPING THINGS FLAT

The key to keeping paper glued down flat is small tears (size of a half dollar or smaller), applying glue under and over every paper tidbit, and applying pressure with the brush over the top. Don't be afraid to push that paper down firmly. Larger tears of paper will often result in a bubble that will catch the light in the finished work, giving away the fact that the work is a collage and not a painting.

JUST SAY NO TO SCISSORS!

You can see that all the pieces of papers I use are torn. I never cut my paper pieces with scissors. I treat each piece of paper as a brushstroke, and therefore I do not want any hard edges. Even when I paint small birds, I create the pupil with a tiny piece of torn black paper, and I even tear the highlight.

Simple Shapes and Paper Tearing

Working in small areas, apply Liquitex gloss gel medium to the wood panel and then lay your torn pieces of paper into this thin layer of glue. (You may need a thicker layer of medium if you are using more textured or heavier papers.) Then brush a second layer of glue over the top of that piece of paper. Apply glue and paper in this "under and over" technique as you add more papers. The over layer provides you with a sticky surface for your overlapping pieces and it helps the paper to adhere to the wood panel without bubbles. Pressing the papers firmly with the glue brush will help to eliminate buckling.

DIRECTIONAL RIPPING

Directional ripping is basically following the form of an object with pieces of collage paper that have been torn into shapes that also mirror that form. Practice this technique by creating round objects like an apple. Focus on shading and creating a feeling of roundness.

You can see this apple has a feeling of roundness for two reasons: Shading and the collage papers are torn in crescent shapes—they follow the round apple form. Larger rounded pieces are layered in the center area of the apple, which appears to be closest to the viewer. Smaller, thinner crescent-shaped pieces are around the edges and in the areas that are farther from the viewer.

The apple exercise (see Part 4) is one of the first things I teach in my workshops. Once you get a feeling for following the form of the apple with directional ripping and shading, you will realize that this form of collage is much like painting.

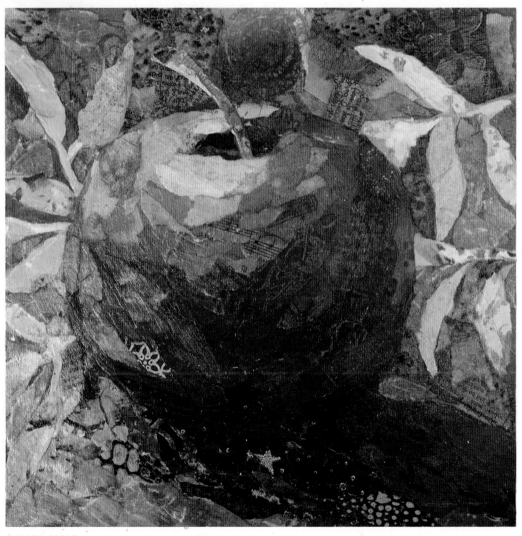

▲ NAPA APPLE
Collage of hand-painted paper on wood panel

Back to Front in the Background

ESTABLISHING ORDER IN THE COMPOSITION

Overlapping edges come forward. For this reason I work back to front in the composition and within the subject itself, saving the foremost areas of the composition (the areas that would be closest to us) for last in collage application. I start with the sky, lay in the middle ground and then overlay the foreground in front of it all. It is only after the background is established that I start on the subject.

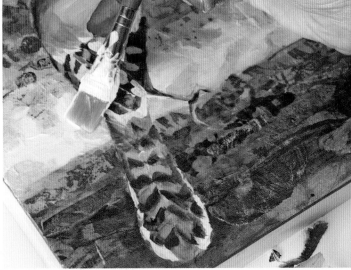

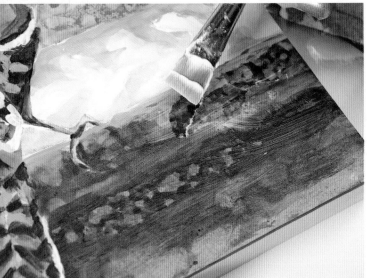

In this collage I start with the grassy area behind the bird at the top. The next step is to lay in the dark area at the bottom. Both of these areas are behind and should be overlapped by the birdbath edge in the middle. After collaging all three of these areas, I apply the blue bird on top.

WHAT LIES DOWN? WHAT RISES UP?

To put it simply, vertical pieces stand up, horizontal pieces lie down. A good example of vertical lines standing up are the collaged lines behind the *Blue Crab Pair*.

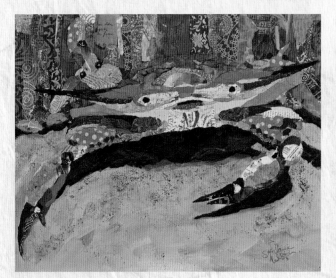

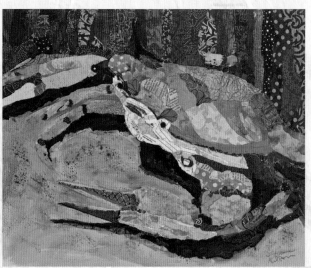

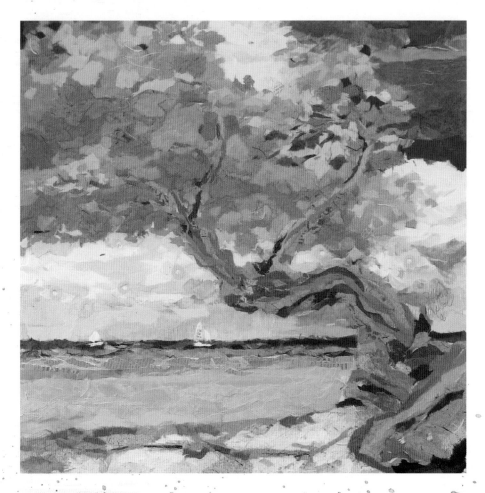

◄ **BEACH TREE**
Collage of hand-painted paper on wood panel

When working in an area of water (or a meadow) that recedes into the distance, horizontal pieces that are wider in the front and gradually get thinner as they go back into the distance are super successful. This painting is a good example. The horizontal strips in *Beach Tree* clearly read as water, and the change from light value to dark value leading from the beach to the horizon line further supports the illusion.

Auditioning Papers

HOW TO CHOOSE WHAT GOES WHERE

Variety is key. Each value of blue should also have a variety of pattern and texture and techniques used to create it. You can never have enough paper!

Establishing good shading and tonal values is an important function of the underpainting so that the paper gluing follows this road map and is successful in achieving volume. I like to create a full range of values of blue paper so I can shade from the darkest dark to the lightest light and every step (at least ten) in between. As a beginner, laying your papers out in a light to dark format may help you in terms of shading.

Back to Front in the Main Subject

ESTABLISHING HIERARCHY IN THE MAIN SUBJECT

1. Starting with the head, lay in the white face.

2. Make use of the white edge as a rim around the dark eye. The eye goes on top of the white face.

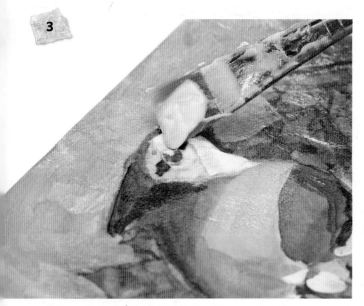

3. Tear a tiny white highlight that sits at the top edge of the eye.

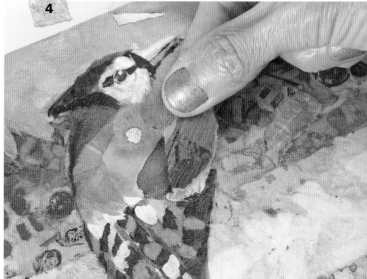

4. The shoulder overlaps the white of the face, so it is the second area to be laid in. The wing and tail feathers overlap the body and are most forward; they are laid in last.

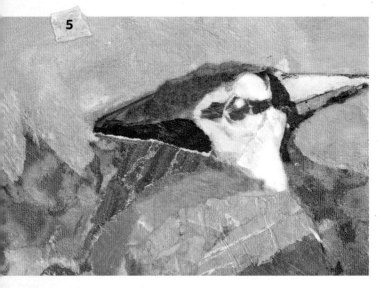

5. The tiny highlight and the white edge rim around the eye help to make it more realistic. All papers are torn, no scissors!

6. Tear the eye with the paper upside down and pulling upward toward you (black is on the other side of the paper facing downward). This technique produces a white edge that works to your advantage when giving the eye a very thin white rim.

7. Small pieces make up the simple shapes of the tail.

8. The key to tearing straight lines is keeping your thumbs close together. In pulling the paper upward toward you, the white edge is eliminated.

9. Lay the centerline down first in the tail so the feathers can overlap into it and make it appear even thinner than you can tear.

WHAT COMES FORWARD? WHAT GOES BACK?

Let's look at another example of composition within the main subject. This time we'll use *How Now, Brown Cow* as our subject. I look at the composition and pick what is farthest back and start there. Bring the background into the next layer, overlapping each layer by about 1/16" (2mm) or 1/8" (3mm). Overlapping is much easier than trying to fit pieces together perfectly. For example, the shoulder and back of this cow need to be laid down first so the head and the ear can overlap that. And the back side of the ear is laid down first before the forehead and eye that overlap it. The front shoulders overlap the body and underbelly. The nose

leading to the forehead and the eye is more forward than anything else in this composition, and therefore is laid in last; the edges of the nose overlap everything else, making this area come more forward than anything else in the composition. Working from back to front:

- Overlapping edges come forward.
- Warm colors come forward.
- Large tears of paper come forward.
- Texture comes forward.

The distant cow goes on top of the meadow, sky and treeline.

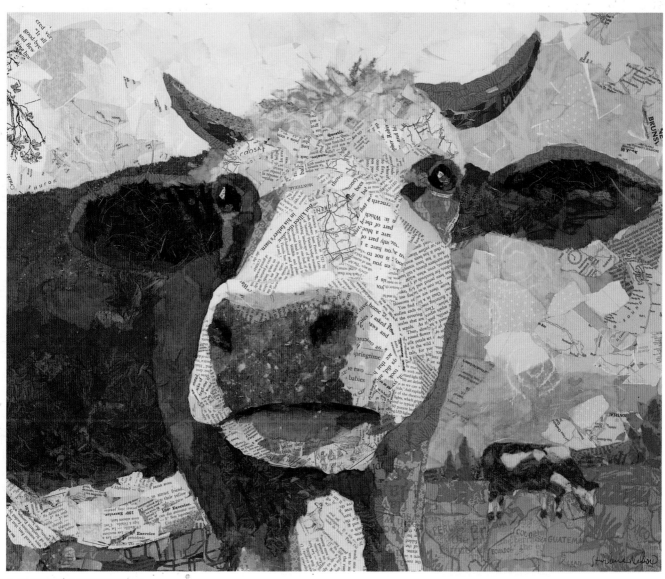

▲ HOW NOW, BROWN COW
Collage of hand-painted paper on wood panel

Separating the Subject from the Background

COLLAGE IS A BUSY MEDIUM and it is important to focus on how to make sure your subject stands out from what is around it and in the background. To simplify, choose whether your subject will be darker or lighter than the background, and work accordingly. Contrasting colors can also help separate the subject from the background. Contrasting or complementary colors are opposites on the color wheel. (You can find color wheels online in the form of charts, or you can purchase one from your local art supply store or view one online. It is very helpful to be able to determine opposite colors when you are painting.)

Another technique I rely on for separating the subject from what's behind it is the level of detail I use. Generally my subjects are pretty detailed and my backgrounds are more simplified. The details help to make the subjects more prominent, especially when placed against a simple background.

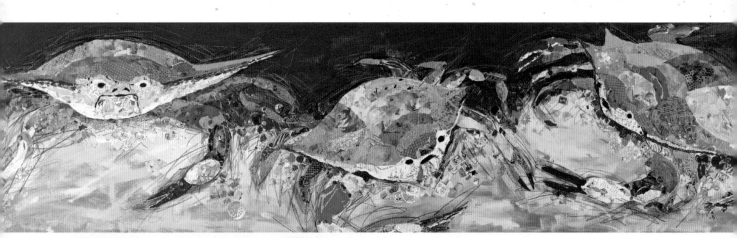

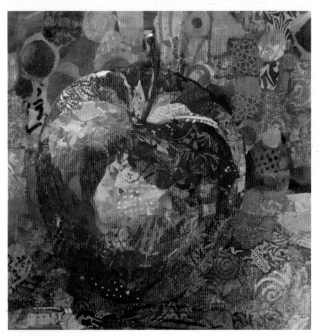

▲ **EMILY'S APPLE**
Collage of hand-painted paper on wood panel

▲ **BLUE CRAB TRIPTYCH**
Collage of hand-painted paper with acrylic, colored pencil and postage stamps on wood panel

Contrasting Colors (opposite colors on the color wheel)
Using contrasting colors for your subject and background not only creates contrast but helps your subject stand out from the background. The yellow bottom of *Blue Crab Triptych* is lighter and warmer and also contrasts with the darker, cool-colored crabs.

In *Emily's Apple*, the red and green colors are not only opposites on the color wheel, they are also opposite temperatures.

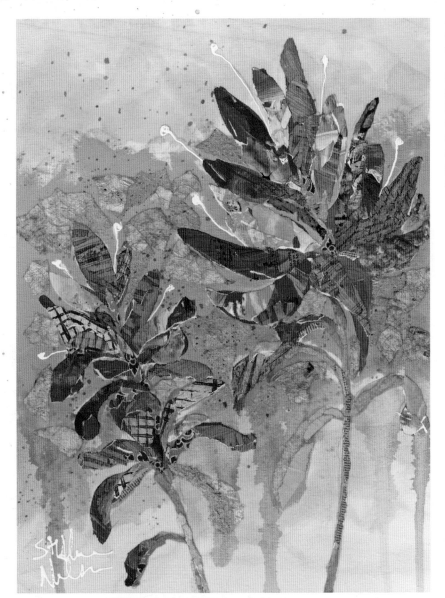

◀ INDIAN PAINTBRUSH #2
Collage of hand-painted paper with acrylic on wood panel

Orange and blue are opposite colors on the color wheel, and this contrast helps the flowers to stand out from the background. Color looks most vibrant when juxtaposed with its opposite color. This is also an example of a detailed subject (the flowers) against a simple background (the blue paper and blue wash of acrylic).

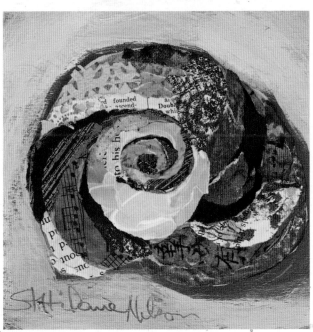

◀ NAUTILUS
Collage of hand-painted paper with acrylic on wood panel

Here we have a subtle example of opposite colors as the sandy background is in a slight yellow hue, and yellow is opposite of purple. Additionally, the shell is much darker in contrast to the lighter background, which also helps to separate the two.

Text and Type

WHITE WITHOUT PAINT

Having been a graphic artist for twenty-plus years, I've had a long-term love affair with fonts and typefaces, or so it seems. My studio is full of books I have collected over the years from used book stores, yard sales and dumpsters (with assistance from my sister). There are even a few new books in my collection. I use the white of the paper along with the size and density of the type to create shading in the white areas of my collages.

If you were to go to the bookstore and spread out several new books, you would find the white of the papers varies. This depends on the quality of the paper and the mill where the paper was created. Use the quality of paper as well as oxidation of paper to your advantage. Yellowed and browned papers appear as they do because of long-term exposure to oxygen; once we seal these papers in glue and varnish, they will maintain their level of oxidation/color.

Smaller body copy type is more dense, and less space between letters and lines creates a darker effect than the larger body copy of children's books, in which there is more white space between letters and lines (and therefore the text in children's books appears lighter than the text in, say, a dictionary or old encyclopedia).

Maps, old book pages, paper doilies, sheet music, menus, handwriting, your grocery list … all are wonderful papers to use for white areas in your composition. Squint and look closely. Which whites are dark and which are light? You can create all the shading you need in white areas from text and type without ever painting any white paper at all.

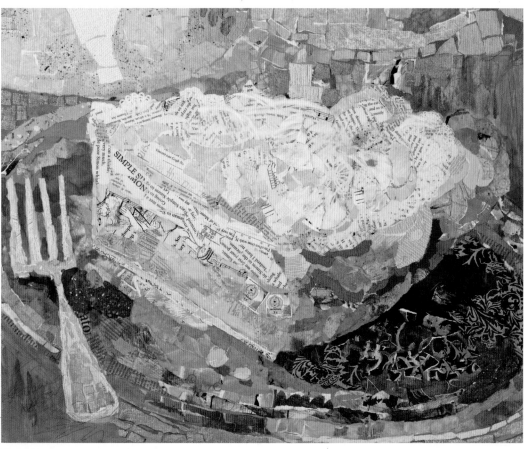

◀ **LEMON ON LAVENDER**
Collage of hand-painted paper on wood panel

The meringue on the pie is a good example of utilizing a variety of text and type in sizes and densities along with oxidized (yellowed from age and exposure to air) papers from old books to create shading and establish values of white without paint.

► GOAT GAZING
Collage of hand-painted paper with metallic acrylic, Gyotaku prints and wallpaper on wood panel

In this piece all of the whites in the face of the goat are from text, type and handwriting. Some of the text is from foreign language books and old grade school homework assignments. I play the violin and so I always enjoy incorporating some sheet music into my work. Several years ago I did a letter-writing campaign via my blog where I asked folks to write me notes that I could include in my work. I promised to each person who wrote to me a letter in return. I was lucky enough to receive letters and cards from all over the world and even some in foreign languages! Handwriting is a lost art form, so any chance I can get to include it in my whites, I do. (If you are going to use foreign language text that is legible, you should probably know the translation.)

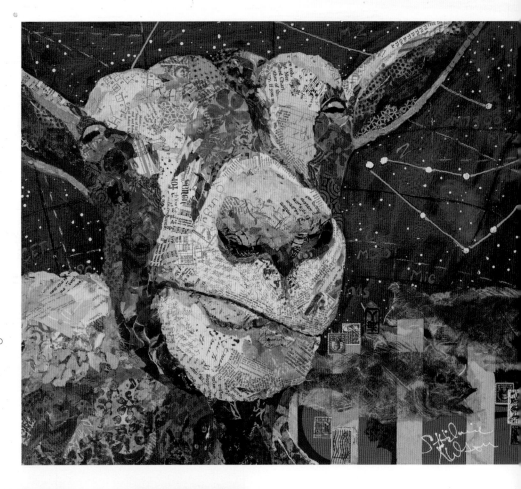

◄ ARNOLD'S GOAT
Collage of hand-painted papers with acrylic on wood panel

In this piece you can see that the left side of the goat is the lighter side, utilizing larger fonts from children's books (which offer more white space in and between the lettering) and whiter papers. The right side is the shadow side of the goat. Here you see oxidized papers and smaller, more dense type treatments.

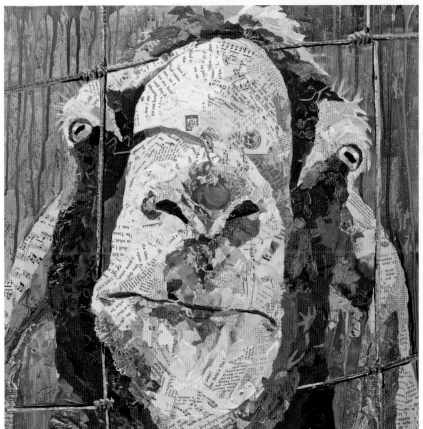

Signing the Work

MAKING YOUR MARK

I sign my work in a variety of ways. If there is an area of restful space and it is light in value, I like to sign in graphite pencil. Often this needs to be done before you start gluing your collage papers on top because the glue offers a slick surface that pencil will not adhere to. However, you can go back into an area and brush on Liquitex clear gesso to give some tooth that you can then write on.

When the signature area is of a darker value, I like to use a white pigment pen. Pigment pens contain paint conveniently housed inside a rollerball pen. The rollerball makes it easy to sign your name in a thin line. I prefer to apply this pen on top of the final varnish coat since the varnished surface is smoother and easier to write on.

If the area I want to sign is of a medium value, I like to use a Faber-Castell Pitt Pen. The Pitt Pen has a fine point and is lightfast and permanent. My personal preference is the dark brown Pitt Artist Pen in a fine point. Like the pigment pen, I use the Pitt Pen on top of the varnish to take advantage of a smoother writing surface. (Many people are surprised to learn that Sharpie markers are permanent, but they are not lightfast—they fade!)

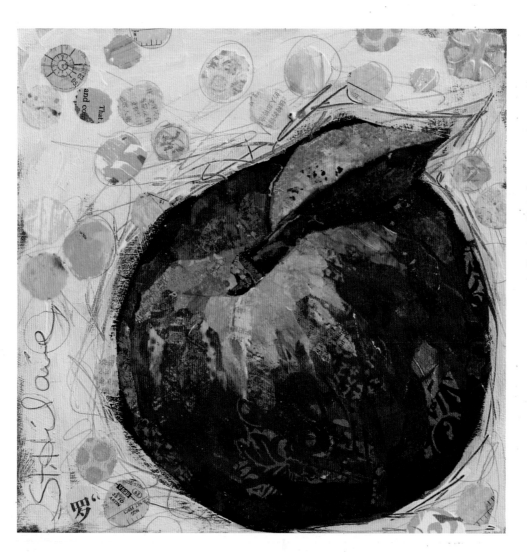

◄ A IS FOR ART APPLE
Collage of hand-painted papers and acrylic with graphite on wood panel (signed with a pencil)

Faber-Castell 9000 graphite pencils feature superior quality, technology and standards. Pencil lead is made from finely ground graphite and clay; it stays put when you apply varnish over the top.

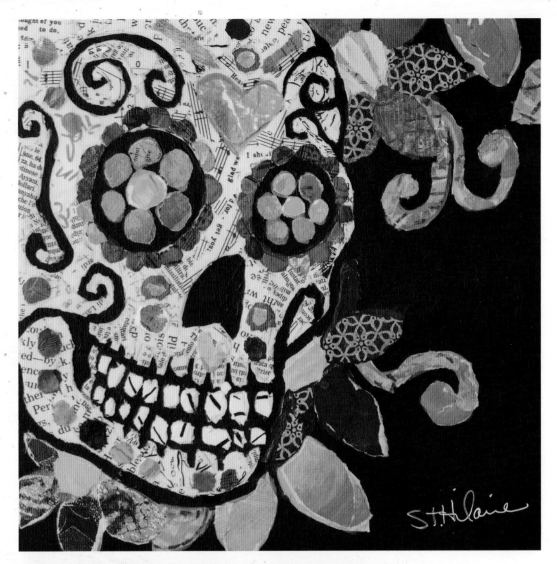

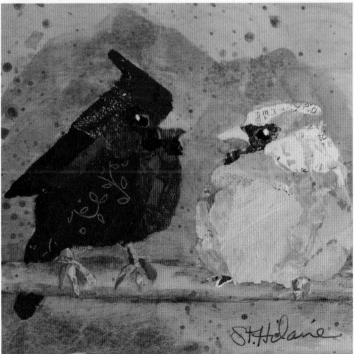

▲ BLUE EYED SUGAR SKULL

Collage of hand-painted papers with black gesso on wood panel (signed with a Uni-Ball Signo Broad Point UM-153 gel pen with white ink)

Enjoy a delightfully smooth and bold writing experience with these Uni-Ball Signo Broad Point gel pens, which will make your signature stand out bright and clear. The gold, silver and white pens are highly opaque and show up well on both light- and dark-colored papers. Like all Signo gel pens, their archival-quality ink is resistant to water and fading.

◄ SHE AND HE

Collage of hand-painted papers with acrylic and colored pencil on wood panel (signed with a Faber-Castell Pitt Artist Pen)

Faber-Castell has brought together all of the advantages of drawing in India ink in a modern and uncomplicated disposable pen: the Pitt Artist Pen. The high-quality brush point works both straight and bent without breaking. Artist pens have unsurpassed lightfastness.

Varnishing Techniques

SEAL AND PROTECT

I frame my collages without glass and without matting. I do this because I want them to be considered paintings, hence the term *Paper Paintings*. After applying two coats of Golden UVLS acrylic varnish, you can put your wood panel directly into frame molding. This glass-free framing allows the viewer to experience all the texture of the various papers you have used—thick and thin papers, book pages and hand-painted papers. Without glass, the varying thickness of the papers is apparent since the light reflects off the collage and not the smooth surface of the glass.

When applying UVLS varnish, work in a well ventilated space and be very careful not to overbrush. Overworking the varnish will cause it to get cloudy and it will dry that way. You want to brush the varnish while it is wet (not when it is halfway dry), working quickly but steadily. If you brush too fast, you'll create air bubbles that will dry into the varnish. Brushing varnish over highly textured papers often causes air bubbles to form, and the best way to get rid of them is to inspect for them, find them and blow on them while the varnish is wet. This should pop the bubbles and there should be no need to overwork the varnish coat with the brush.

UVLS varnish has UV light protection and it is absolutely a necessity. There are varnishes available that do not have UVLS, and these should be avoided. Allow each varnish layer to dry completely before applying the next.

Collage is very forgiving. If you find that your varnish has clouded in an area due to overbrushing (or even if you decide there is a part of the art that you do not like after it has been varnished), you can always go back in with gloss gel medium and add another collage layer over the problem area. Let it dry, and revarnish the whole piece. (I do not recommend varnishing small areas; I'd rather see you put a full coating over the whole piece for an even surface.) This type of reworking is successful because the varnish and the gel medium are both acrylic-based products; they work hand in hand with each other.

I have changed the color of the entire background of a piece after it was varnished because I decided that it just wasn't working. And I have also overworked my varnish and clouded it. The best thing about collage is that you can always add another layer.

Move the brush in a slow and steady motion to avoid varnish bubbles. Apply a thin, even coat—no pooling or puddling.

Edges

SHADOW AND LIGHT, LOST AND FOUND

Edges help the form to advance and recede. "Found edges" are what I call sharp, well-defined edges. Found edges typically show up in the areas where the subject is most well lit. "Lost edges" are those that typically occur in the shadows. It's okay for the edge of the subject that meets the shadow area to be almost totally undetectable. I liken this to getting up in the middle of the night and seeing everything in your room in shadows. The colors are gone, the definition between objects is blurred. Shadows soak up all details and color. This same effect needs to occur in painting in order for the shadow areas to recede.

▶ **BLUE BATHER**
Collage of hand-painted paper on wood panel

Lost edges include where her body is in the water; found edges are where her body is out of the water. You can see the softness of her edges blending into the blue in her legs and in her arms. The lost edges are formed by bringing translucent blue papers to overlap the fleshtones and to bring some of the fleshtones out into the blue. Also, using some transitional papers in the middle that have both flesh and blue tones on them helps to bridge the gap and further soften the edges.

Found edges are sharp, defined edges like the top of her shoulders, which are very clearly out of the water. The flowers on the bathing cap are also sharp and found as they too are out of the water and stand out. The simple shapes of the flower petals on the cap are suggesting versus precisely rendering the floral cap. Collage is an impressionistic medium.

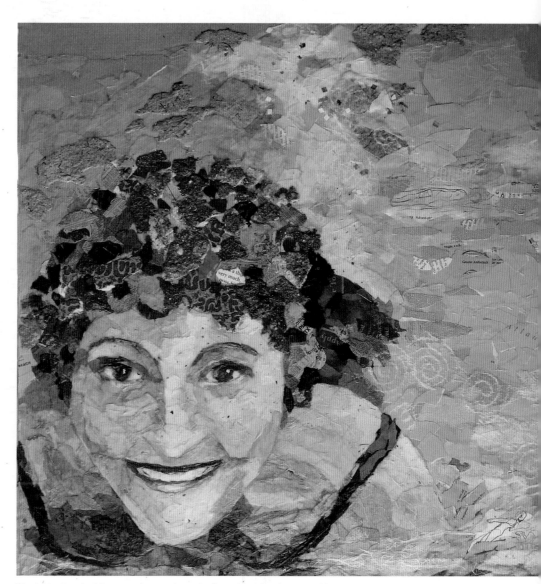

The lost edges in this example are where the figure is under the water. Her exposed shoulders and face are found edges.

Restful and Negative Space

GIVING THE EYE A BREAK

For as much as I love color and busy, busy, busy collage papers, there is something to be said for an area that uses low-contrast patterning, which I refer to as "tone on tone." In this area the contrast stays low and the value of the papers stays close and similar so that when you squint through your eyelashes and look at it, nothing jumps out at you. The area comprises a single value with no pops of dark or light to interrupt the smoothness of it. This is restful space and necessary in every composition. A place for the eye to linger and take a break from all the wonderful patterning of the collage papers that make up the rest of the composition is like the balance of the yin and yang. Restful space can be even more successful if it's of a neutral color, which adds yet another level to the calming effect.

Every composition needs some smooth, restful space. As much as I love busy, busy and lots of bright color, the viewer's eye needs a place of calm to rest in, even for just a minute. Consider the compositions here as examples of such.

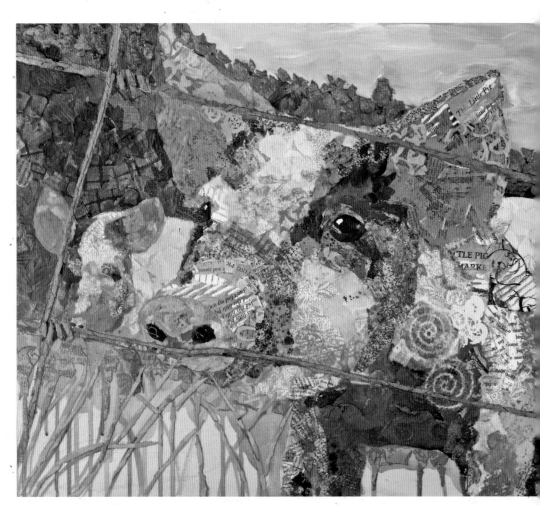

▲ **PIGGLY WIGGLY #2**
Collage of hand-painted papers with acrylic on wood panel

The smooth, restful space is the diagonal created here by the blue painted sky. By contrast this area is low in pattern and smooth in texture, allowing the eye to rest from the exciting colors, textures and tucked-in related text on the foreground pig. The greenery is also highly patterned and textured as is the drippy green grass at the bottom. In addition to the natural blue sky, you can also note smoother, more restful areas in the smaller background pig (this helps him separate from the foreground pig) along with the back body and forehead of the foreground pig.

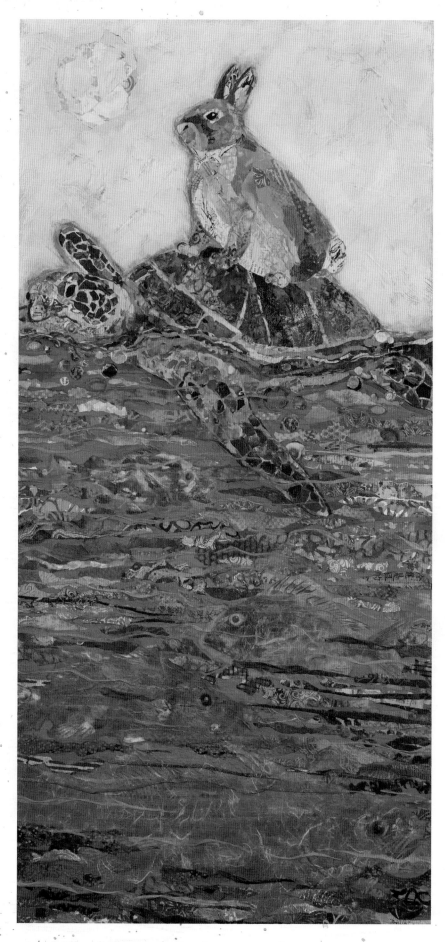

Collage of hand-painted papers with acrylic, gesso, and Gyotaku prints on wood panel

The smooth, restful and negative space here is the golden yellow of the top background. It was created by adding multiple layers of gesso with a palette knife, applying a shade of darker ochre paint and wiping it off with a paper towel so that it sits only in the recessed areas of the gesso, then applying a lighter golden yellow on top, wiping lightly to allow some areas to be lighter than others.

The Gyotaku artist is Chuck Seaman, who exhibits in Key West with me. He provides me with imperfect and test prints from his process to incorporate into my work. Gyotaku (Japanese, from *gyo* "fish" + *taku* "rubbing") is the traditional Japanese method of printing fish, a practice that dates back to the mid-1800s. This form of nature printing may have been used by fishermen to record their catches, but it has also become an art form of its own and is practiced around the world.

Arbitrary Color

EMBRACE THE UNEXPECTED

Representing the dark areas of a dairy cow with deep purples and blues rather than the more expected shades of gray and black makes for a much more interesting painting. Shading the cow with values ranging from extra dark purple to light periwinkle is considered to be using arbitrary color; it's unexpected. But this can be a difficult concept to get right. It seems to be about color, but more than color, it's about value. As long as the value range is light and dark enough (and everything in between) for the shading to form volume and dimension, it doesn't matter what color it is. Shading, shading, shading—this is the

key. What is light? What is dark? How dark or light is it in relation to itself and in relation to what's around it? You can use any color you want in paper painting; you just need to get the values right.

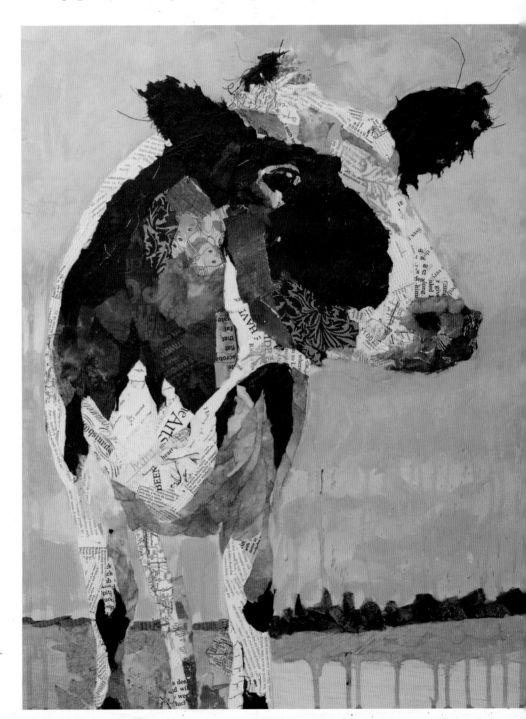

▶ **LAZY AFTERNOON**
Collage of hand-painted paper with acrylic on wood panel

Mixing It Up

COMBINING MIXED MEDIA WITH COLLAGE

One of the more rewarding things about being a collage artist is that there is no such thing as off-limits materials or mediums. I can pull out the Prismacolor sticks, the Derwent Inktense pencils, the charcoal, the graphite, the Conté crayons, you name it, whenever I want! Don't be afraid to scribble in the background of your piece with pencils, to lay rich blacks down around your subject with chunks of charcoal you still have from your college days (oh yes, my supplies go way back) and just experiment. Almost anything can be adhered to your surface with gel medium, so go ahead and experiment with 3-D pieces if that's what your heart desires.

I experiment with mixed media mostly in the underpainting stage, but that is just my style. Why not try your own combination of materials both on top of and underneath what you glue down?

Your art will take on a life of its own throughout the creative process anyway; why not foster even greater creativity? Frequently what I end up with is not necessarily what I had in mind when I started. But that's okay. You have to be open to the journey; follow your instincts and your heart.

▲ NAOMI TRUMPET VINE
Acrylic paint, paper and charcoal on wood panel

Related Materials

THE EASTER EGG EFFECT

Weaving related materials into your composition makes for something that not every viewer finds … only those who take the time to linger. When the viewer finds that little tidbit (stories about a dog within the dog's body, swimming illustrations in the water of an ocean scene, nursery rhymes within the body of that same storied animal), he or she feels like they've discovered a treasure! It's important to weave and tuck these related materials into your work in a way that is subtle.

You don't want to make it too obvious; don't simply plop your Easter egg on top. The plopping effect does not give the viewer as much joy as actually stumbling upon the material. The joy of the Easter egg effect comes in the hunt.

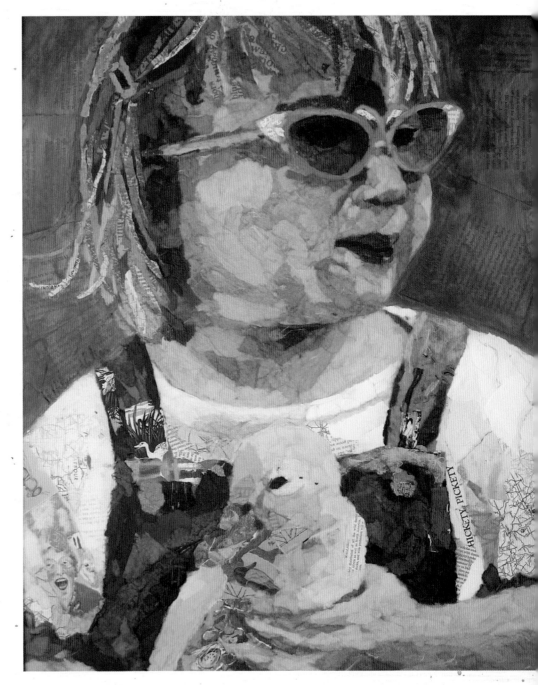

▶ DUCKY
Collage of hand-painted papers with acrylic on wood panel

This is a portrait of my daughter, Emilie, at the petting zoo around age four. She's now almost eighteen and headed to college this year.

Within her overalls you can see illustrations of ducks and poems including "Hickety Pickety" in her white shirt. There is a nest with an egg, a duck and the definition of a mallard in the yellow of the duckling.

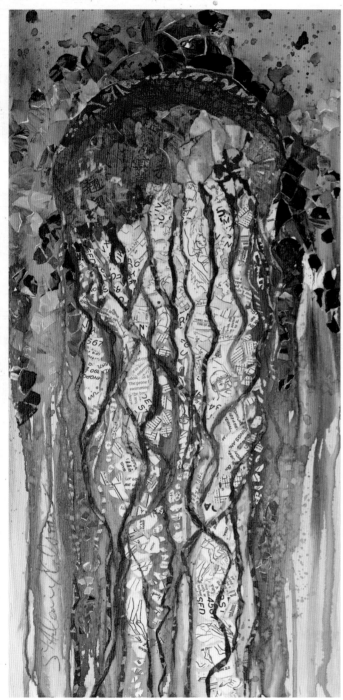

▲ SEA JELLIE
Collage of hand-painted papers with acrylic on wood panel

Related materials include illustrations of swimmers and a person with a snorkel and fins in the white areas.

▲ BLUEBERRY BLISS
Collage of hand-painted papers on wood panel

Within the pie are tidbits of "Simple Simon, The Pie Man" poem from 1973's *Best Loved Nursery Rhymes*, a book my mother read to us as children and I ripped up as an adult. Also along the front edge of the plate: "Did Dr. Jay bake this pie?" "My friend Jody baked it." From my son Connor's kindergarten school workbook. [He's sixteen and 6'1" (185cm) now.]

Creating Collage: Putting It All Together

IN MY PAPER PAINTINGS COLLAGE WORKSHOP, we always start with an apple. Why apples? Because if you can render the very basic shape of a sphere in collage, give it shading and create volume, then you can take what you learn and apply it to more complex shapes. For all the eggs I had to draw in art school, followed by cones, spheres and cubes, I give you the far more interesting apple.

A sphere can be rendered like the earth with longitude or latitude, meaning that the directional ripping of the apple can be successful either vertically or horizontally wrapping around the form, and sometimes a combination of both directions. This helps the student to learn how to apply directional ripping, to follow the form and to create dimension of a simple shape.

You may change this up with another simple sphere fruit or veggie; I have also painted oranges, peaches, pears and blueberries to mix up my repertoire. They all offer that simple shape, with a range of color and texture that exceeds eggshells by far!

GRANNY'S APPLE
Collage of hand-painted paper on wood panel

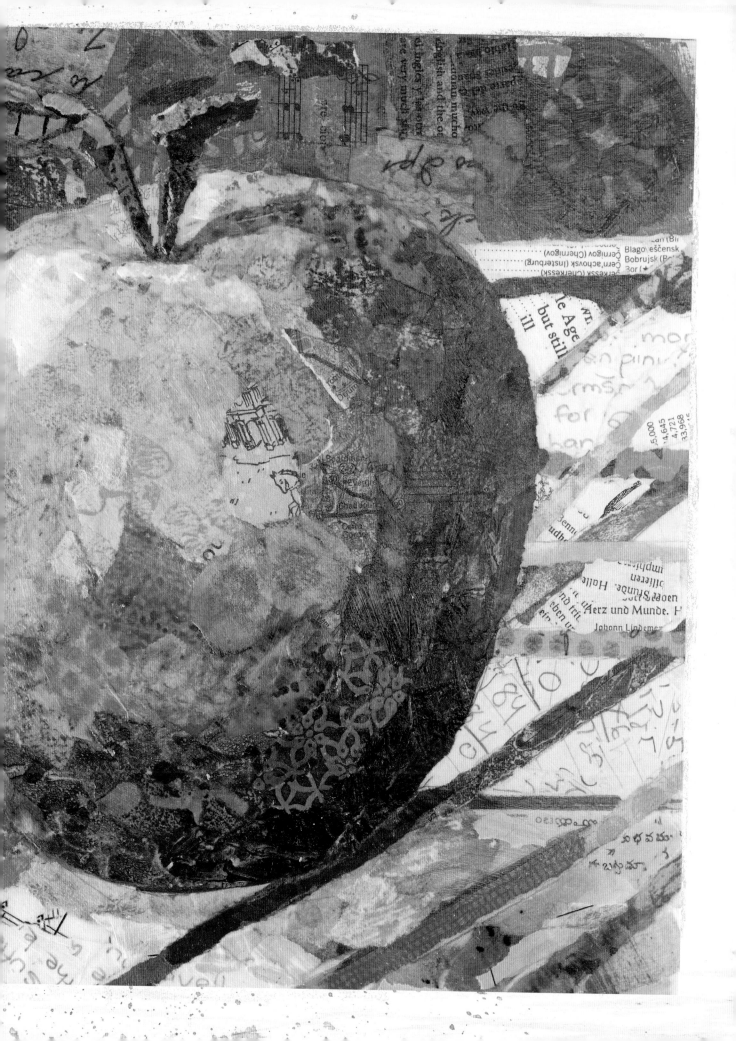

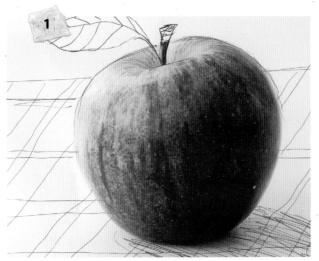

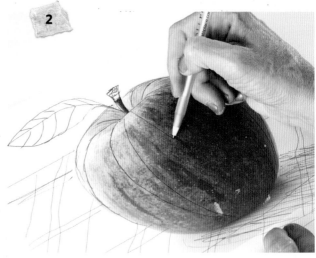

1. Composition Manipulation

Cut out an image of an apple and place it on a piece of paper. You can cut other photos up to create your background, but since I couldn't find exactly what I was looking for, I decided to draw in the background—a simple tablecloth. I also opted to draw in a larger stem, a leaf and a shadow.

2. Mark up the Reference Photo

Look closely at the striations and marks on the skin of the apple to determine what direction your brush marks or torn paper will follow. I see vertical direction here, longitude lines that follow the form in a vertical direction. Marking up the apple reference photo helps to visualize the direction the tears of paper will follow.

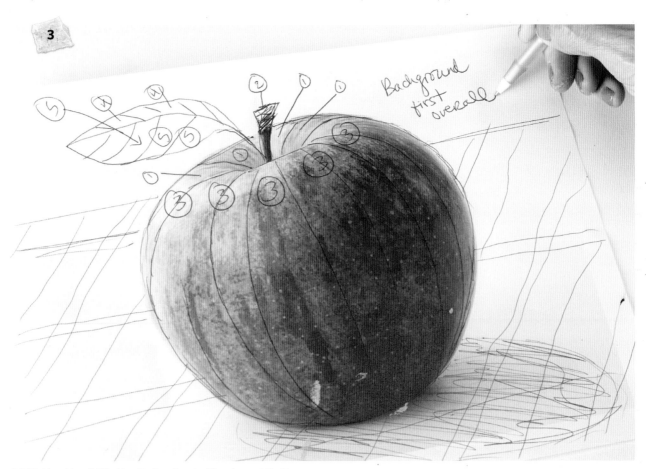

3. Thinking Ahead: Working Back to Front—Mapping out the Process

It is helpful, especially when you are just starting out in paper painting, to completely map out your process as I have here. Remember, you will always start with your background. You will move on to your main subject, establishing a hierarchy based on what part of the subject is closest to you and which areas have the most overlapping paper edges. In my composition, after the background I will complete the areas near the top of the apple, which also will be the lightest value areas. I'll follow that area with the stem, then the body of the apple and then the leaf. (Assign numbers to the individual parts of the apple. Lower numbers like 1's and 2's will represent the first areas you will collage—these are the areas farthest from you. Higher numbers like 4's and 5's will be the last areas you collage, as they are the areas closest to you.)

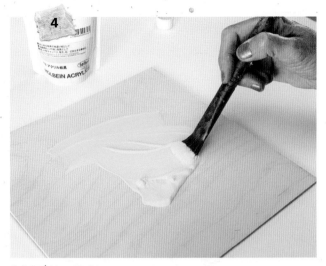

4. Prime Your Surface

If you are using a wood panel, seal it with gesso or Golden GAC-100. I've decided to used a colored gesso from Holbein—I've decided to change the color of my apple from predominantly red to green. This colored gesso will work perfectly as a base color for my apple. Allow the gesso to dry completely.

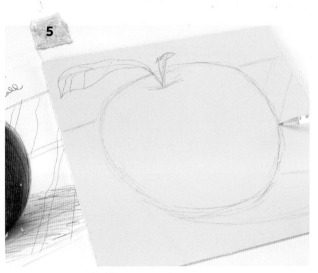

5. Sketch Your Composition

Using your composition reference as a guide, sketch the main subject and background onto the gessoed panel.

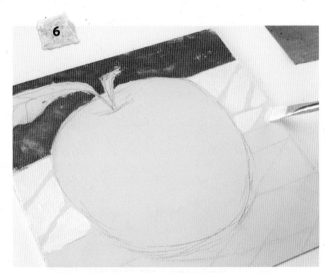

6. Begin Your Underpainting: Painting the Background

Start at the top (or the farthest back) in your composition and paint your largest swathes of color. Work your way through the background, continuing with your largest shapes. The top or farthest part of my composition is orange, which I chose because it will complement the green of the apple nicely. The main color of the tablecloth with be white, and I am painting around the colored stripes that are to come: I am doing so (rather than painting the colored stripes over the white) to maintain the location of the stripes. (If I painted over them after sketching, it might be difficult to paint them where I intended them to go.) When I apply collage to those stripes (drawn on the underpainting), some of the underpainting shows through, which I like. Conversely, I do not want any white to show through.

7. Continue the Underpainting: Painting the Shadow Area

Paint in the next largest part of the background, the shadow area. Again, paint around your stripes, filling in the boxes created by the stripes.

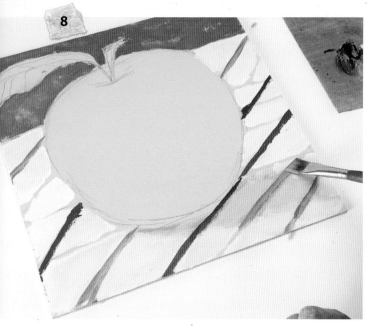

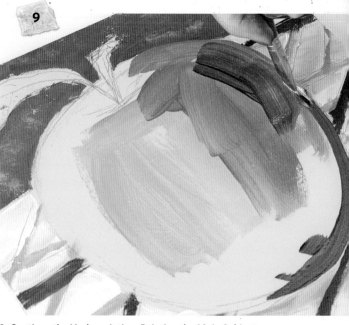

8. Continue the Underpainting: Painting the Stripes
Paint in the stripes. Paint over the gessoed lines. It is fine if a bit of the colored gesso shows through.

9. Continue the Underpainting: Painting the Main Subject
This part is important in the sense that it is the perfect time to work out your values—you need to place your light, dark and medium tones now. Refer to your reference and remember to work with your light source and shade. And remember not to labor too much over this part of the process; the point of the underpainting is to help you determine where your values are and what colors you'll use in your collage.

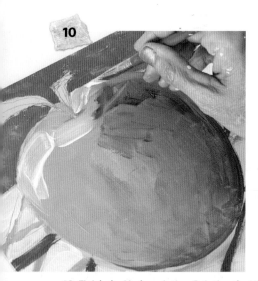

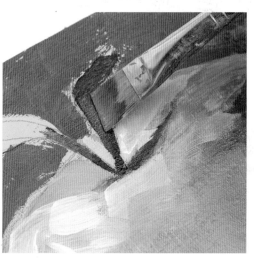

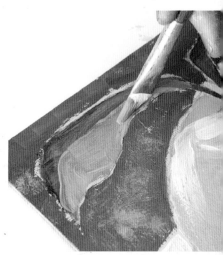

10. Finish the Underpainting: Painting the Highlights and Diversifying Values
Continue painting following along with your composition reference. Don't forget to add highlights near the top of your apple where the light is hitting it and your values are the lightest. You will also want to add a bit of diversity in values to your stem to make it appear more realistic and dimensional. Finally paint the leaf, again using your reference to aid in representing values.

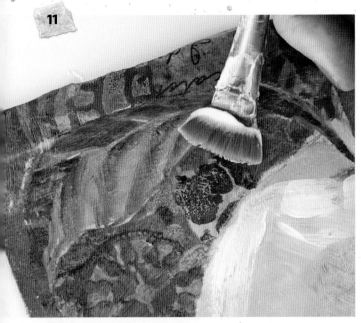

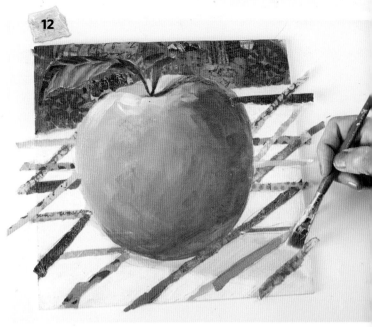

11. Collage Application: Work Back to Front

Begin to glue down your paper pieces. Remember to work in small areas and work back to front in your composition. Apply gel medium to the panel and lay your torn pieces of paper into the glue. Brush a second layer of glue over the paper. Press papers firmly with the glue brush to eliminate bubbles and prevent buckling.

12. Collage Application: The Stripes

Next let's collage in the stripes. You will need to tear thin strips of paper (don't be tempted to cut your paper with scissors) to fit the composition. Feel free to let the papers run off the edges of the panel—we will come back later and trim them after they have dried.

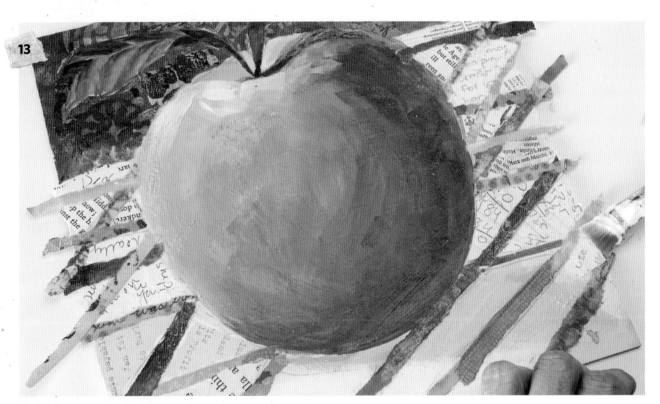

13. Collage Application: Text and Type

Collage the white of the tablecloth using bits of white paper (white in its many shades and variations, of course) that contains text and type. The papers you use here may include pages from old books, sheet music, old letters or documents, and handwritten lists and notes. Make sure you have plenty of variety in the types of paper and in the density of type/text.

After you finish collaging in your whites, you'll want to fill in your shadow areas with bits of violet paper in a variety of light and medium values.

14. The Main Subject: Working Back to Front
It's time to check in with your reference again. Remember when we numbered the parts of the apple to help us determine when and how to apply collage to our main subject? Now is when that prep work pays off. Begin collaging the top of your apple. This area is the "back" of the "work back to front" of your main subject.

15. The Main Subject: The Stem
Collage the stem. You will want to use a variety of values to add a touch of realism and dimension to this area of the composition. Note that I've added lighter values to the top and left of the stem; keep in mind that this is where our light source is hitting.

16. The Main Subject: Start the Leaf
You'll collage the leaf in three parts. Start by collaging the entire leaf with darker value papers. When you are finished, this paper will peek through and represent the veins and edges of the leaf. Add midvalues to the bottom half of the leaf. Use small pieces to represent the individual sections between the veins.

17. The Main Subject: Finish the Leaf
Finish the leaf by adding small torn pieces of paper in lighter values to the top half of the leaf.

18. The Main Subject: Begin Auditioning Papers

It's finally time to build the body of the apple. We will mold and form the roundness of the shape by auditioning papers that have been directionally ripped and exemplify a wide variety of values. Directional ripping is basically following the form of an object with pieces of collage paper that have been torn into shapes that mirror that form. Directional ripping along with careful shading creates a feeling of roundness. The paper pieces you are working with now will consist mostly of semicircular and crescent shapes that will comprise the edges of your apple. Move your individual ripped papers around the body of the apple until you find areas that match both their values and shapes. At this point, in addition to focusing your efforts more on the perimeter of the apple shape, you should also be working from dark to light.

19. The Main Subject: Continue Auditioning Papers

Continue to audition papers until you are happy with your selections. The paper in the photo on the left is too light for that area, and it's too dark for the area shown in the middle photo. But it's just right for the selected area in the photo on the right.

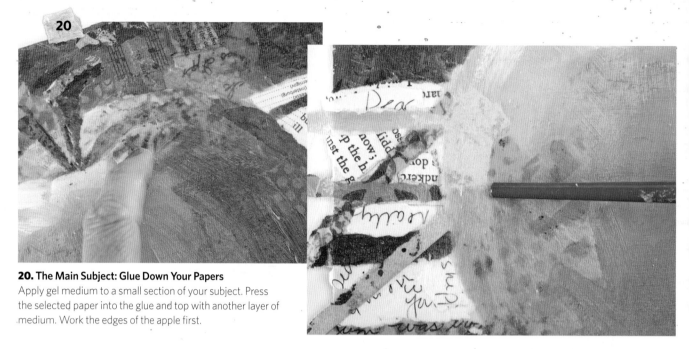

20. The Main Subject: Glue Down Your Papers
Apply gel medium to a small section of your subject. Press the selected paper into the glue and top with another layer of medium. Work the edges of the apple first.

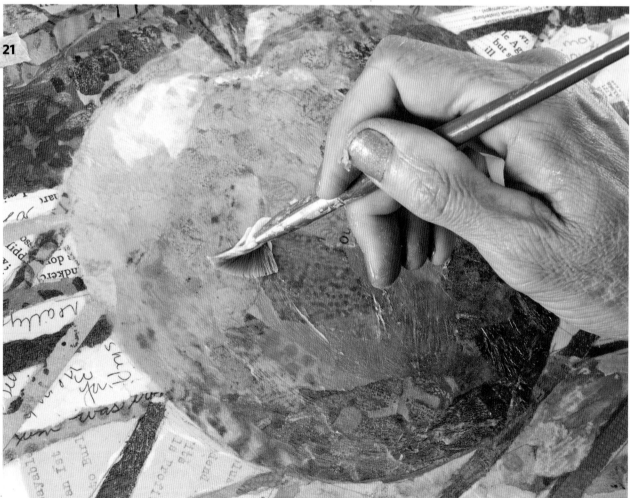

21. The Main Subject: Finish Adding Collage Papers
Continue gluing down paper, working toward the center of the apple. Layer larger, rounder pieces in the center area of the apple, which appears to be closest to the viewer. This continues to add to the fullness and roundness of the subject.

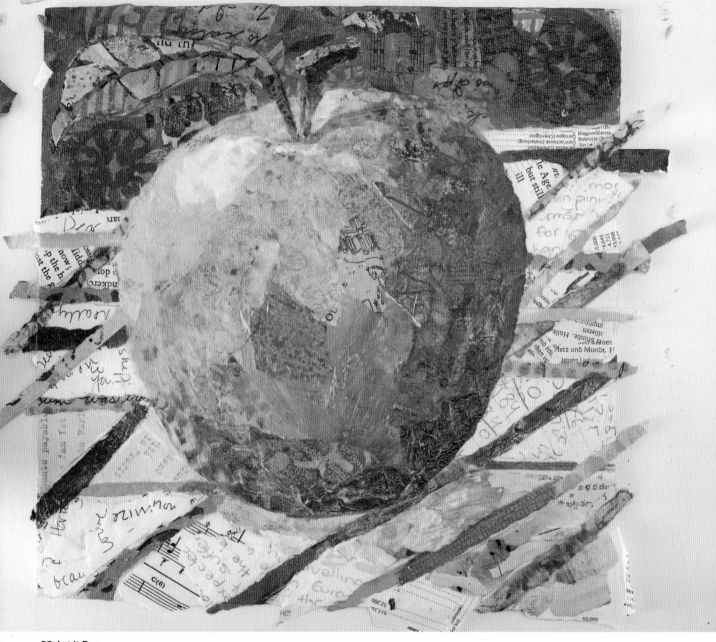

22. Let It Dry

Allow your painting to dry completely. This may take as long as a day.

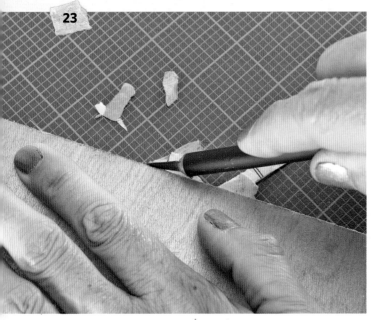

23. Trim Excess Paper

Turn your panel over, and using a craft knife, trim any excess paper so that all edges are smooth.

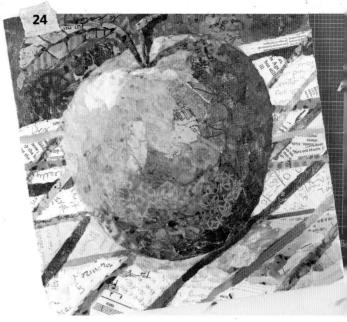

24. Flip Your Paper Painting Over Again

Make any adjustments you want at this time. You may find, for example, a little more paint showing through in an area than you'd like, or maybe you feel a value is off. Take the time now to fix such issues if desired. Also look for a good spot to add your signature.

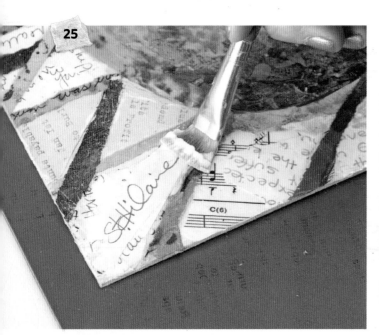

25. Add Your Signature

Sign a small scrap of paper and glue it onto your collage with gel medium, both under and over. In this example I'll lay my signature into one of the text-and-type areas.

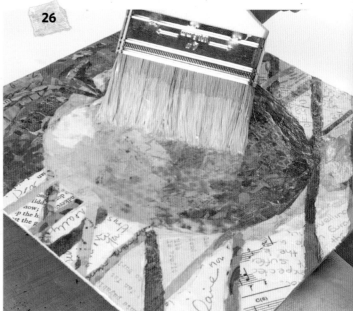

26. Apply Varnish

Apply varnish with a wide brush. Be sure to work in a well-ventilated space, and be careful not to over brush, which can result in a cloudy finish. Allow the varnish to dry completely and then add a second coat of varnish. After the second coat has dried completely, you are free to hang or frame your paper painting as desired.

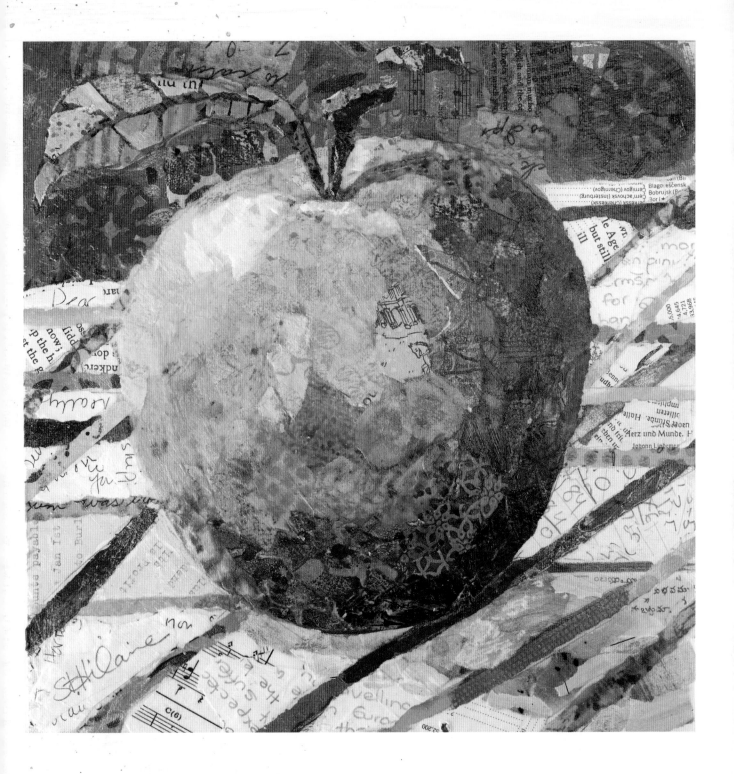

Gallery: Art and Inspiration

SOME OF MY FAVORITE COLLAGES are born out of experimentation. In fact most of them are. I am constantly experimenting with new materials in my process such as silver and copper leaf, metallic paint, colored pencil, charcoal, Gyotaku prints, wallpaper, house paint and molding paste. In some pieces I let the wood grain show through clear primer, and on some pieces I collage right to the edges and wrap around without any wood or background paint left showing. Lately I've been working on die-cut wood where the subject protrudes out of the square picture plane. I collage pieces anywhere from 6"× 6" (15cm × 15cm) to 6' × 6' (183cm × 183cm) and everything in between. I've painted animals, botanicals, still lifes and portraits; no subject is off limits. I work from my imagination, I take commissions, I try to paint what the market demands, but sometimes I paint things that just make me happy.

The very best thing about mixed media is that endless combinations of materials can go hand in hand with collage, so I am never bored. That's great news for someone with boundless energy but a short attention span!

▶ **BLUE**
Collage of hand-painted paper, blue gesso and silver leaf on wood panel

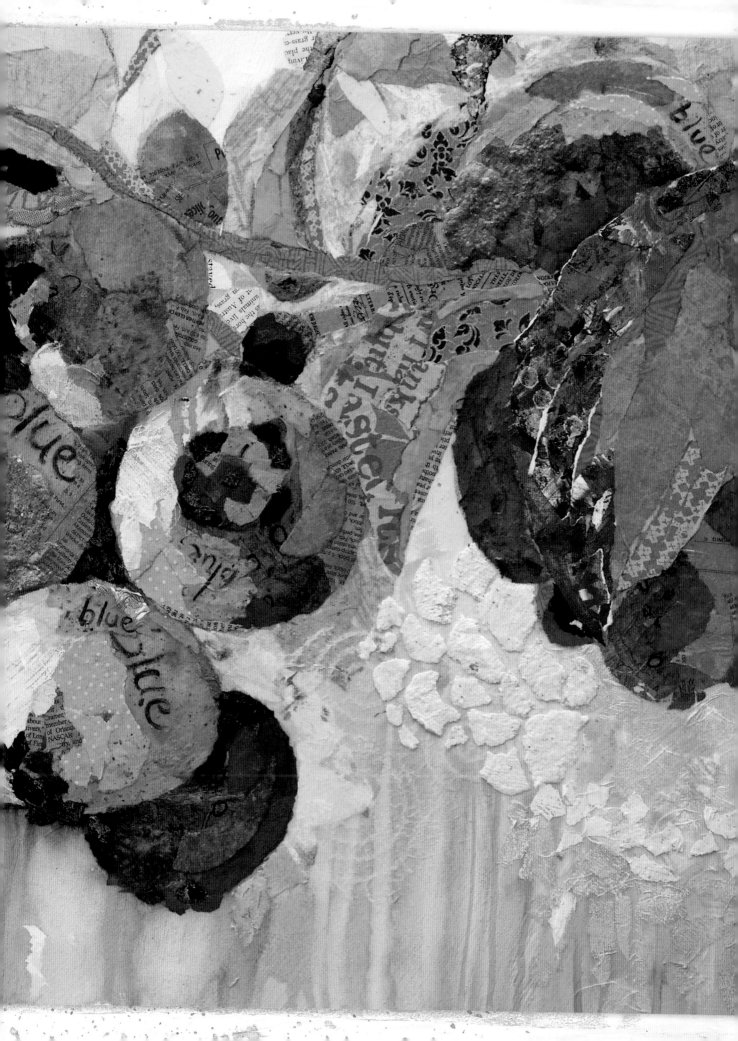

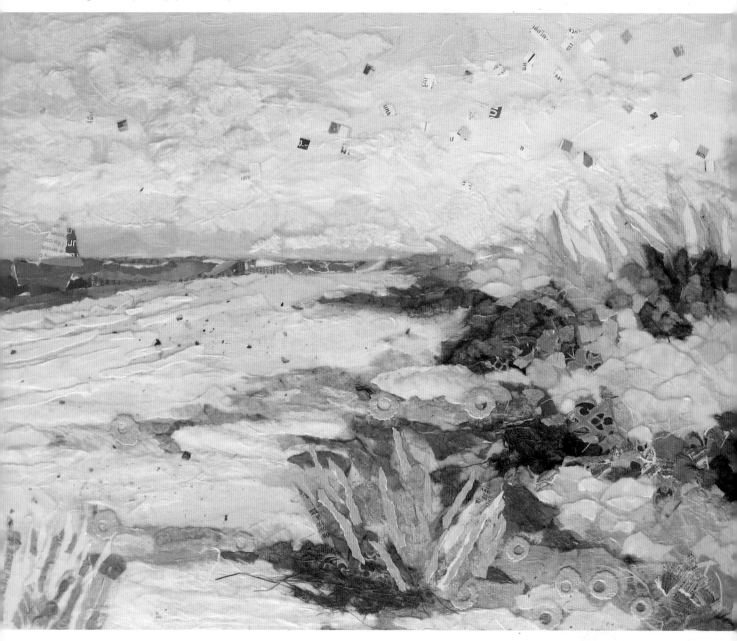

▶ **TANGERINE DREAM**
Collage of hand-painted paper
and acrylic on wood panel

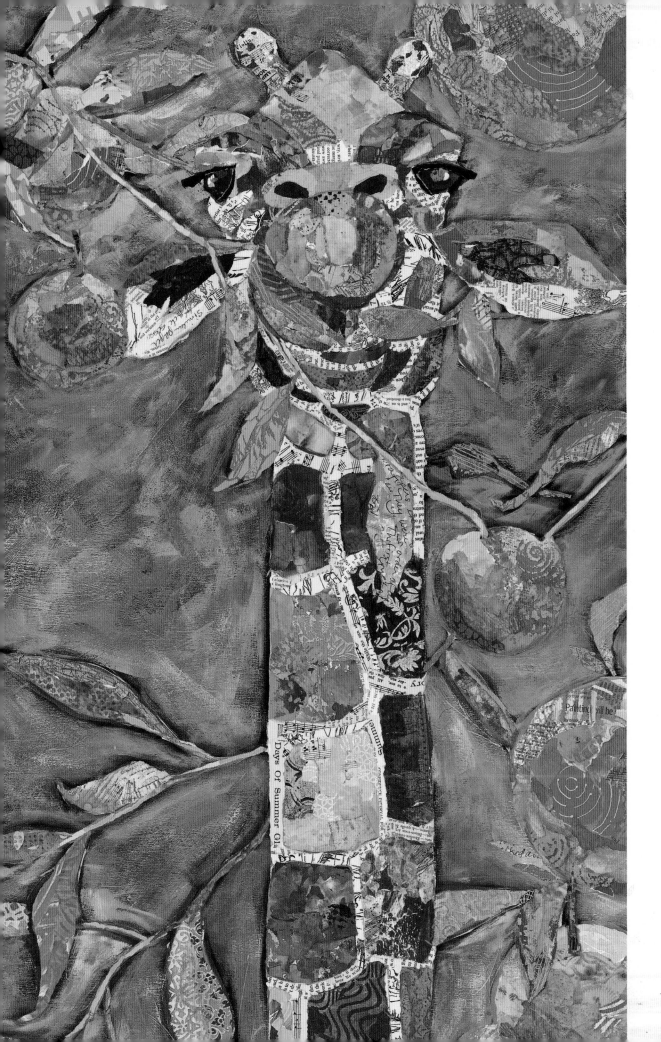

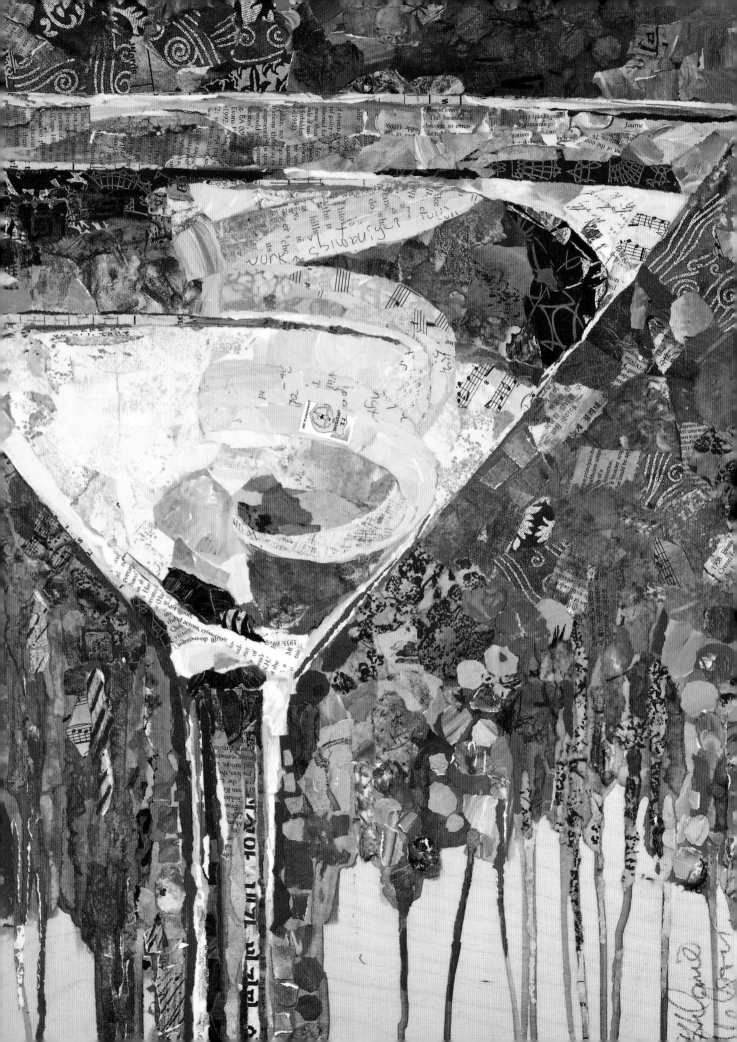

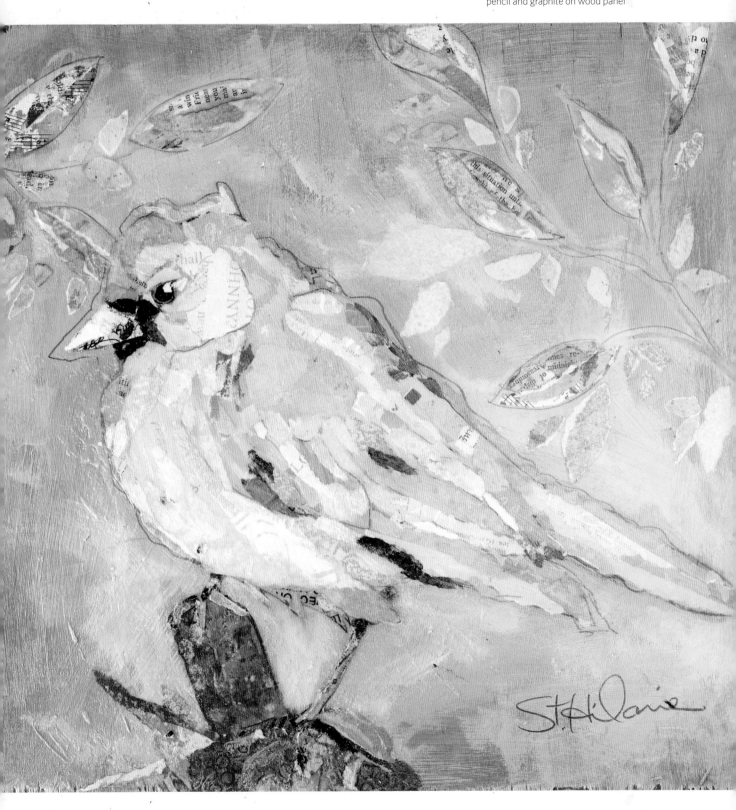

▼ **FINCH**
Collage of hand-painted papers with colored
pencil and graphite on wood panel

◄ **IN GOOD SPIRITS #1**
Collage of hand-painted paper on
clear primed wood panel

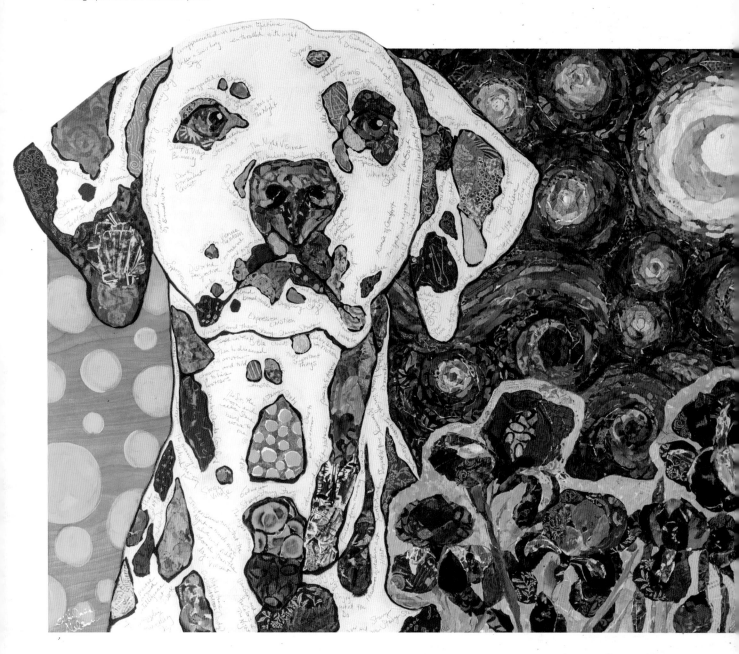

▼ STARRY STARRY NIGHT
Collage of hand-painted papers with acrylic
and graphite on die-cut wood panel

► SUNNY
Collage of hand-painted
paper on wood panel

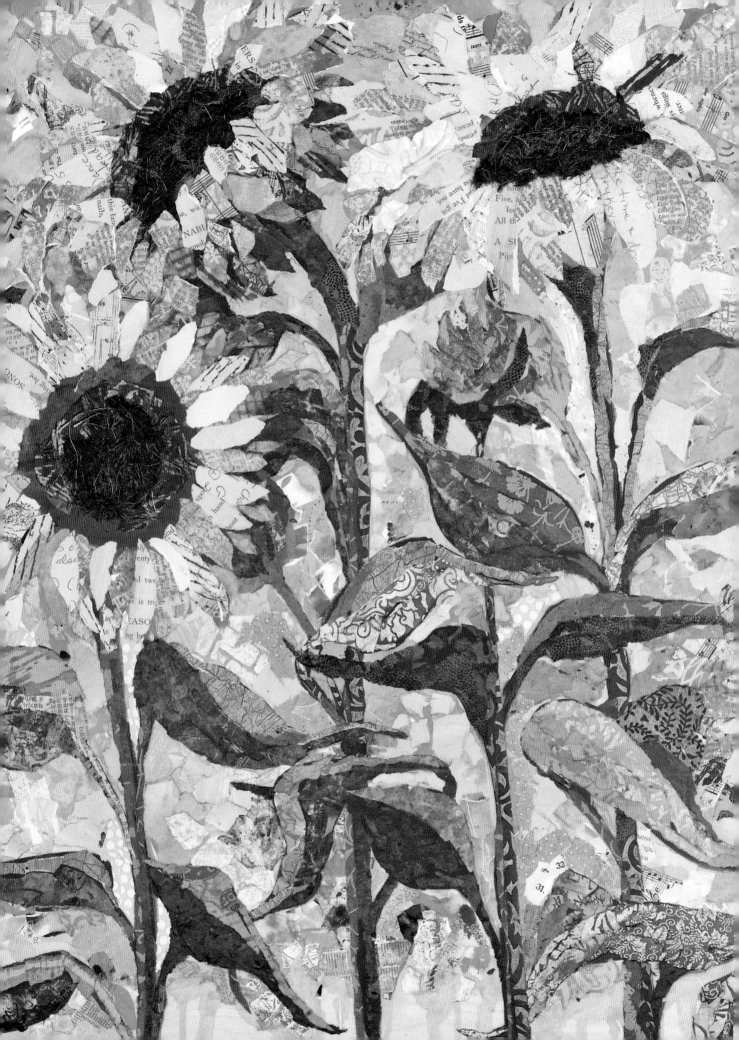

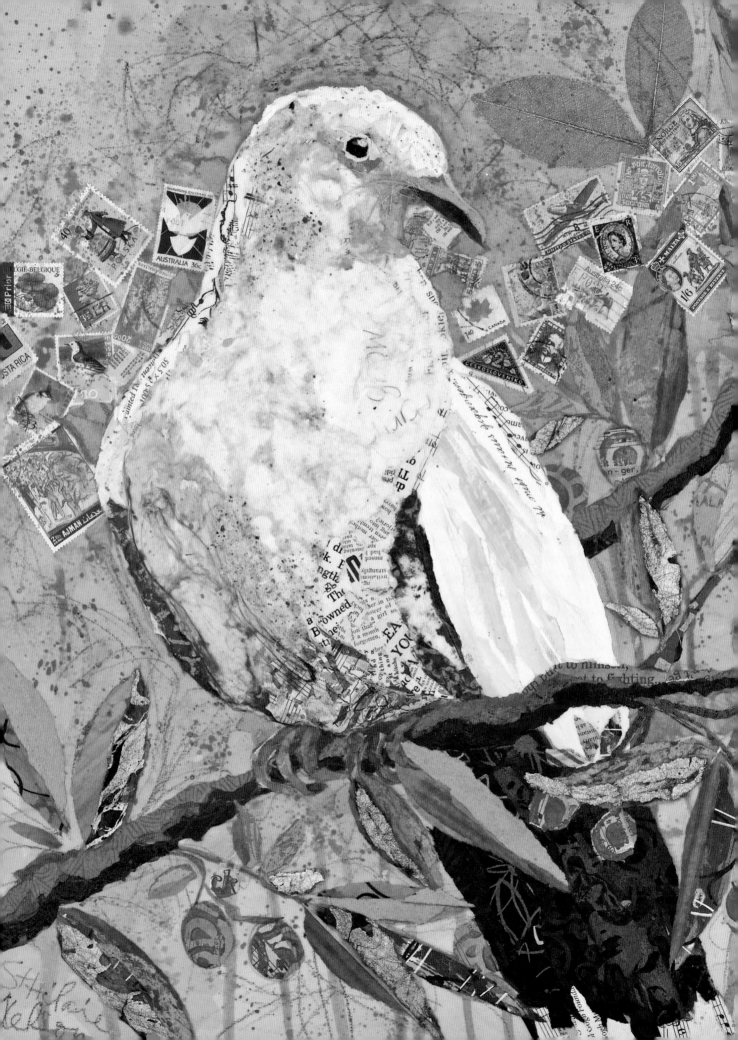

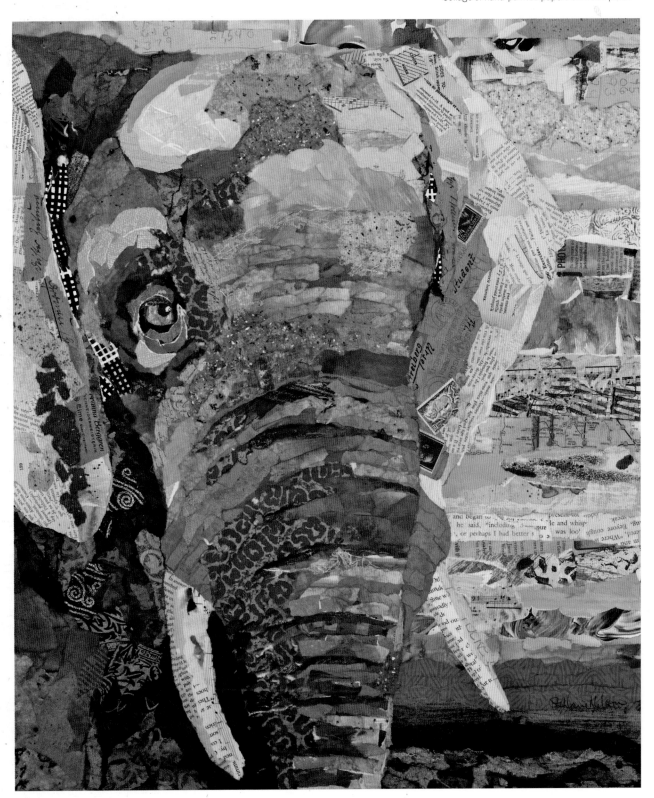

◀ **GLOBAL PEACE DOVE**
Collage of hand-painted papers
and acrylic with colored pencil and
postage stamps on wood panel

▼ **JAMI'S PEACOCK**
Collage of hand-painted paper on wood panel

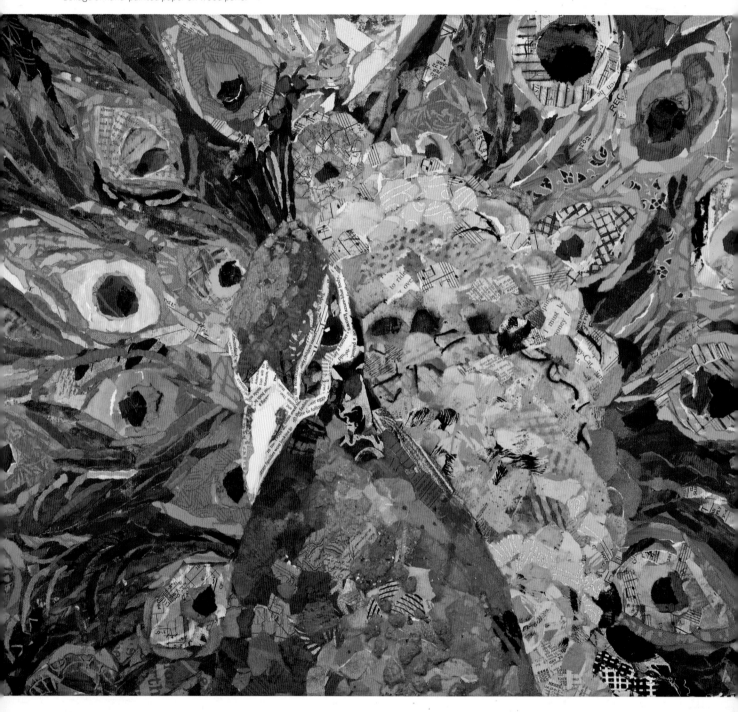

▶ **INDIAN PAINTBRUSH #1**
Collage of hand-painted paper and
acrylic on clear primed wood panel

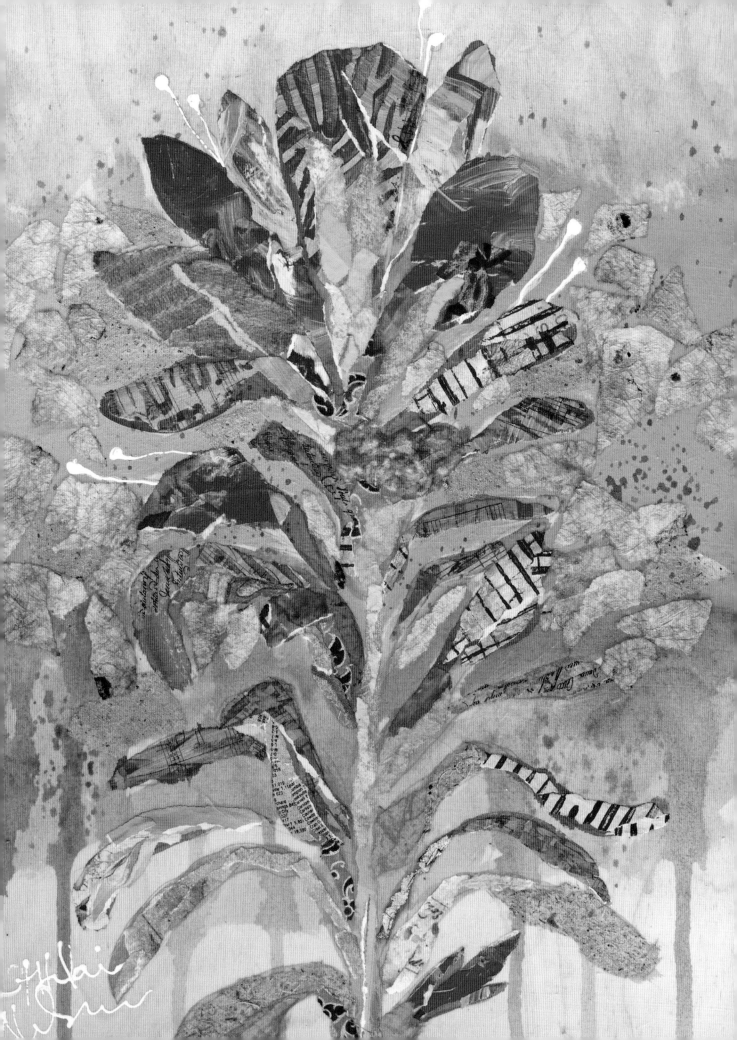

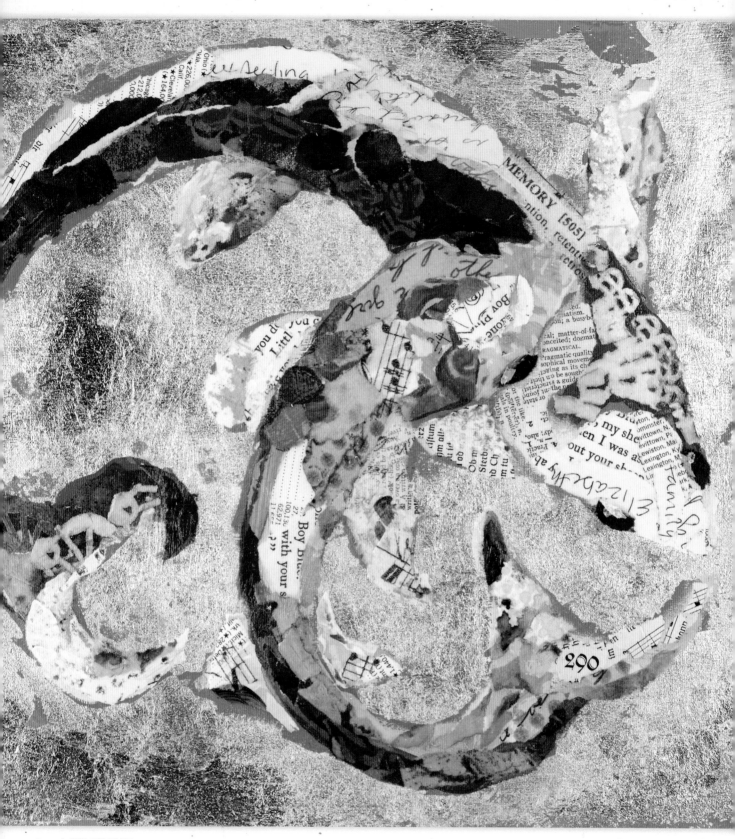

▲ KOI ON BLUE
Collage of hand-painted paper, blue
gesso and silver leaf on wood panel

Index

**NORTH
LIGHT
BOOKS**

An imprint of Penguin Random House LLC
penguinrandomhouse.com

ISBN 978-1-4403-4311-7

Printed in China

10 9 8 7 6

Editor: Kristy Conlin
Designer: Clare Finney
Photographer: Christine Polomsky

METRIC CONVERSION CHART

To convert	to	multiply by
Inches	Centimeters	2.54
Centimeters	Inches	0.4
Feet	Centimeters	30.5
Centimeters	Feet	0.03
Yards	Meters	0.9
Meters	Yards	1.1

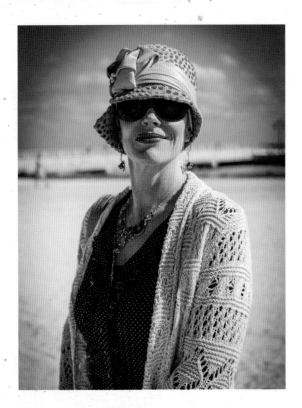

ABOUT ELIZABETH ST. HILAIRE

Born and raised in New England, Elizabeth has lived in central Florida for the past twenty-plus years. She holds a B.F.A. in advertising design from Syracuse University, which prepared her for a dual identity as both graphic designer and fine artist. These days she's a full-time fine artist whose only graphic design client is herself.

Elizabeth has earned Signature Member status with the National Collage Society and crisscrosses the country several times a year to take her paper tidbits on the road. Teaching and sharing her collage technique through an intense three-day Paper Paintings workshop has become a passion.

Elizabeth's work has also been published in *Acrylic Works 3: Celebrating Texture* (2015) and *Incite 2: Color Passions* (2014), both by North Light. A feature article on her work appeared in the April 2014 issue of *The Artist's Magazine*. She was also a finalist in *The Artist's Magazine* Annual Art Competition (2014 and 2015) and took first place in the category of Collage/Mixed Media for *The Artist's Magazine* All Media Competition (2010). She was an award winner in the National Collage Society's Signature Member Exhibit at the Mesa Contemporary Arts Museum, in Mesa (2013). Online, Elizabeth was a finalist in the Richeson75 Arizona International Art Competition (2013).

Learn more about Elizabeth and her art at paperpaintings.com.

DEDICATION

For Emilie and Connor,

Thank you for loving me for who I am, for supporting me in what I do, and for understanding both.

ACKNOWLEDGMENTS

Thank you to my parents, Al and Jane St. Hilaire, and my four siblings for letting my creativity flourish no matter how crazy the project or how big the mess. (Remembering Halloween …)

A huge thank you to my Westfield, Massachusetts, high school art teacher, Barbara Chiampa, for encouraging me to go to art school, for facilitating special projects just for me and photographing them for my portfolio—for believing I could make it.

Heartfelt appreciation to my kids for enduring my absences while teaching or opening a gallery exhibit, which inevitably means I am absent for the occasional swim meet, dance competition, rowing regatta or school function. At times we all suffer for my art.

Thanks to all the amazing folks at North Light Books for their hard work and dedication to making this book possible. To Tonia Jenny for discovering me, to Kristy Conlin for editing me down and reeling me in, to Christine Polomsky for her beautiful photos, which were woven into a stunning layout by Clare Finney … it's been an amazing new experience all the way around. Here's to new experiences!

Thank you to everyone who follows me on Facebook, reads and takes the time to comment on my blog, and who graciously accepts my marketing efforts in their inbox. Hugs to those of you who have taken classes and workshops from me both in person and online and who have purchased originals or prints. I could not make it as a full-time working artist without all your generous support!

Thank You
for being
a part of my
Art Journey.

Elizabeth